MARINE PAINTING

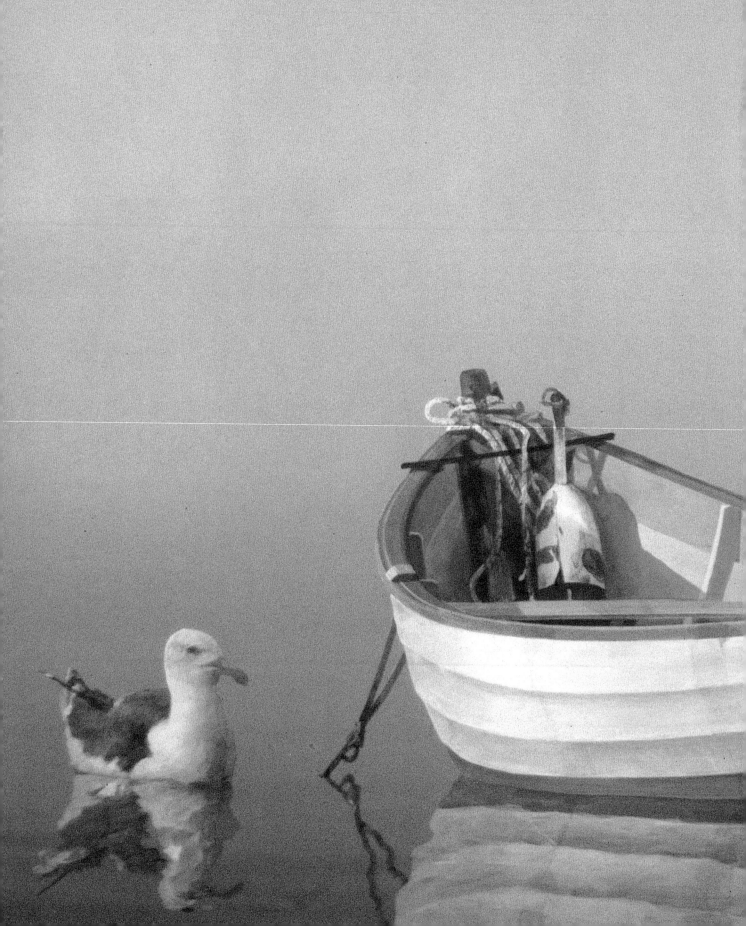

SUSAN RAYFIELD

MARINE PAINTING

TECHNIQUES OF MODERN MASTERS

Watson-Guptill Publications/New York

Edited by Paul Lukas
Designed by Jay Anning
Senior Editor: Marian Appellof
Graphic production: Ellen Greene
Set in ITC Garamond Light

The author and publisher gratefully acknowledge *Boston Magazine* for permission to reprint quotations appearing on page 66, which originally appeared in the article "Ships of Gold" in February, 1987.

First published in 1991 by Watson-Guptill Publications,
a division of BPI Communications, Inc.,
1515 Broadway, New York, NY 10036

Library of Congress Cataloging-in-Publication Data

Rayfield, Susan.
 Marine painting : techniques of modern masters / Susan Rayfield.
 p. cm.
 Includes index.
 ISBN 0-8230-3006-7 (hardcover)
 1. Marine painting—technique. I. Title.
ND 1370.R28 1991 91-11156
751.4—dc20 CIP

Manufactured in Singapore

First printing, 1991

1 2 3 4 5 6 7 8 9 / 95 94 93 92 91

PAINTING CREDITS

Frontispiece:
Vern Broe, *Seabrook Skiff,*
24" x 36", acrylic, 1985

Page 8:
West Fraser, *Hutchinson's Fish House Interior,*
50" x 38", oil on linen, 1990

Pages 10-11:
Donald Demers, Schooner *Yosemite off Isle of Shoals, N.H., circa 1895,*
12" x 16", oil, 1988

Pages 28-29:
Vern Broe, *Seabrook Fisherman,*
24" x 48", acrylic, 1985

Pages 48-49:
Carl G. Evers, *Hurricane,*
21" x 24", watercolor, 1989

Pages 62-63:
John Stobart, *Savannah. Moonlight over the Savannah River in 1850,*
24" x 40", oil, 1987

Pages 76-77:
John Stobart, *Flying Cloud,*
28" x 36", oil, 1967

Pages 90-91:
Loretta Krupinski, *Monhegan Harbor,*
21" x 32", oil, 1987

Pages 104-105:
James R. Harrington, *Malagash Regatta,*
18" x 24", oil, 1988

Pages 122-123:
Frank H. Wagner, *Stars and Stripes,*
20" x 26", gouache, 1988

For my godson, Andrew Morton, with all my love

Acknowledgments

My gratitude, above all, to the artists who participated in this book. Their kind generosity made it possible. A special thanks to Vern Broe, for the use of his library.

Russell Jinishian, director of the Mystic Maritime Gallery in Connecticut, provided invaluable support throughout—putting me in touch with many of the artists at the outset, and providing other key contacts in the marine-art world as well.

I am deeply indebted to Dori Hoyne, wife of the late Tom Hoyne, who died while this book was in progress. Access to his speeches and papers was essential in completing his sections of the book. Dori also supplied many transparencies and drawings. Of equal assistance was Hoyne's longtime friend and fellow artist Charles Kessler, who reviewed Tom's paintings with me and shared his own memories of the great painter.

I would also like to express my thanks to Jean Evers, wife of marine artist Carl Evers, Sandra Heaphy, of Maritime Heritage Prints in Boston, Mary Nygaard, of Mill Pond Press in Venice, Florida, and the staffs of the Greenwich Workshop in Trumbull, Connecticut, and Janus Lithographs on Hilton Head Island, South Carolina, for their generous help with the artists they represent. The editors of *Nautical Quarterly, Sea History,* and *Boston Magazine* kindly granted me permission to quote from their publications.

Chris Rector, at the Bayview Galleries in Camden and Portland, Maine, was encouraging at the launch of this project. Jim Costello, publisher and general manager of the *Sun-Journal* newspapers in Lewiston, Maine, cast a sailor's eye on the result.

Finally, my colleagues at Watson-Guptill deserve special praise: Paul Lukas, for his perceptive editing; Marian Appellof, for developing the layout; Executive Editor Mary Suffudy, long a friend and mentor; and Jay Anning, for his wonderful design. My thanks to all.

CONTENTS

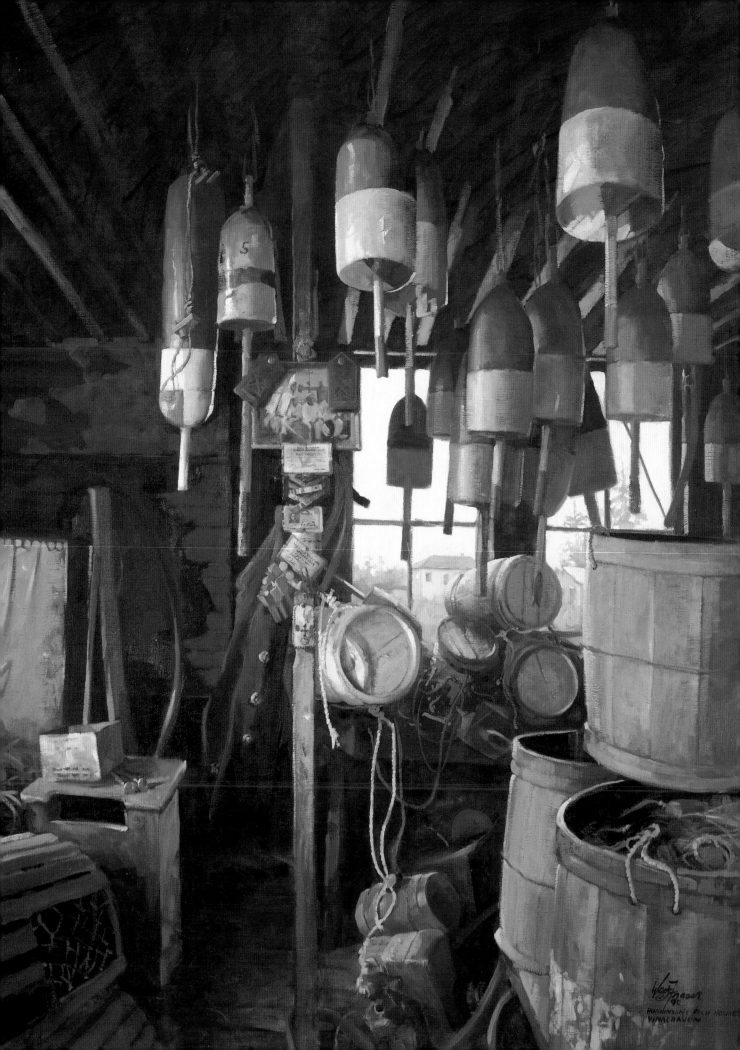

FOREWORD

When well-known nineteenth-century painter James McNeill Whistler was challenged in a London court by John Ruskin, the leading art critic of the day, to explain why he would expect a customer to pay 1,500 pounds—then a tremendous sum of money—for a painting that took Whistler only 90 minutes to paint, Whistler's reply was succinct: "No, Mr. Ruskin, I expect that payment for a *lifetime* of work." Indeed, as most artists will agree, the process of perfecting the craft of painting involves a lifetime of continuous study.

Each time a painter, no matter how novice or experienced, sits down before an empty canvas and picks up a brush, he instantly becomes one in spirit with every other artist who has ever attempted to express himself in paint. But this does not mean that the skills of every preceding artist are automatically transferred to his hand, of course—becoming proficient at painting, like mastering anything else, involves a great deal of hard work, individual effort, and, usually, formal training. However, with the apprentice system having been abandoned some time ago, good instruction is not easy to come by, and contemporary artists often have to spend an inordinate amount of time searching out answers to questions that have plagued painters for centuries. This can be a frustrating experience, particularly given the solitary nature of the profession, which does not encourage the easy exchange of information. However, help has now arrived in the form of this fine book by Susan Rayfield.

Inside, you will find unique technical advice and philosophical guidance from some of the very best marine artists working today. The ultimate goal of every artist involves discovering a particular view of the world and developing the skills to express it, but listening to other artists "talk shop" about their systems and their work can provide specific and practical solutions to common painting problems and the reassurance that you are not alone in the struggle.

The sea has always been among the most challenging, beautiful, and evocative places on our planet, looked to as a source of inspiration and adventure from the beginning of time. Marine artists throughout history have made it their special task to tell the compelling story not only of the sea, but also of ships and the crews who sailed them.

But just as our world has changed dramatically since people first took to the sea, so too has our definition of marine art expanded considerably. Where clipper ships on the high seas once set the standard in the marine art field, today there is almost nothing related to the sea that is not considered suitable subject matter for the motivated marine artist. As a result, recent years have seen this very traditional art form completely transformed, as more and more accomplished artists have turned their considerable talents toward investigating and documenting every aspect of nautical life, from recreations of specific moments in maritime history to the pure feeling of speed and power of a great modern sailing yacht. In fact, today's marine art comfortably encompasses small dinghies, class sailing vessels, fishing vessels, tugs, tankers, freighters, destroyers, submarines, and so on, as well as marine mammals, well-known landmarks like lighthouses, islands, port towns, and beaches. This great richness of subject matter has helped to make this the most exciting and dynamic period in the long history of marine art.

The following pages contain some of the heretofore best-kept secrets in the marine painting field. Through the extraordinary generosity of spirit so characteristic of these artists, they share with us the individual methods and techniques that have taken them years to develop and perfect. Beginners and accomplished marine painters alike will find this volume to be a fascinating and indispensable part of their working libraries.

Enjoy, and good painting!

J. RUSSELL JINISHIAN
Director, Mystic Maritime Gallery
Mystic, Connecticut

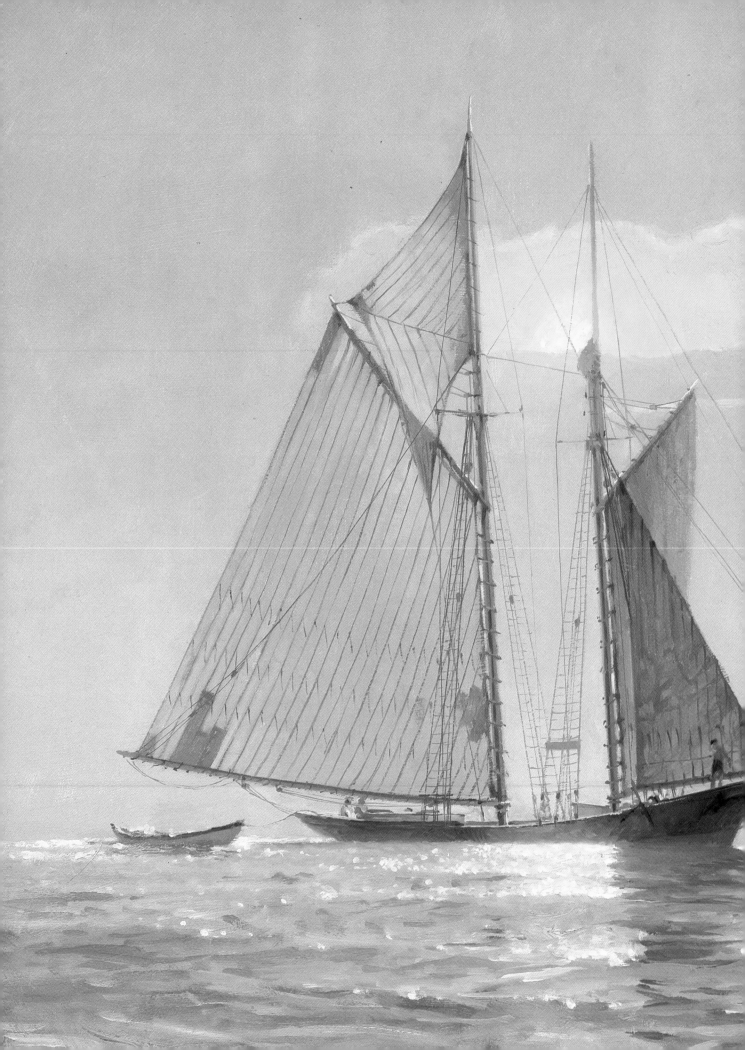

THE PLEASURE
OF SAILING

WEAVING COLOR WITH CROSS-HATCHING

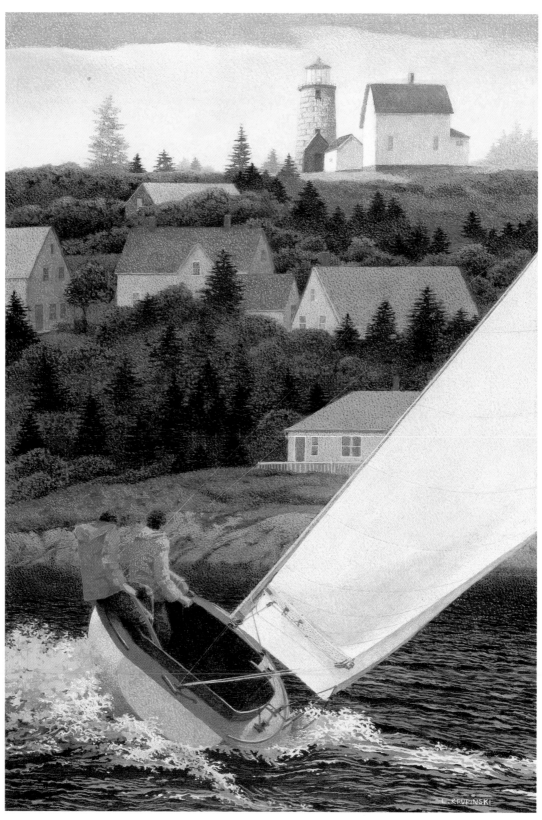

MONHEGAN LIGHT
21" × 14½" (53.3 × 36.8 cm), oil, 1987

Loretta Krupinski brings a refreshingly different approach to the tardition of marine art. Working in oil, she builds up layers of color by means of underpainting, glazing, and delicate cross-hatching, resulting in luminous paintings reminiscent of the Impressionists and pointillism.

Krupinski attributes her style to her former career as a newspaper illustrator. Her drawings then included tones created by tiny crisscrossed lines. Working in that unforgiving medium taught the artist more than just technique—she learned to think in terms of juxtaposed shades of light and dark, which in turn made her sensitive to tonal changes; she learned to plan for positive–negative space; and she learned to think ahead and know where she was going, an important lesson because, as she puts it, "Once you put ink down, you can never go back." Krupinski's transition to color was natural. "Cross-hatching helps build up or decrease the amount of color," she explains, "making a subject more sensitive to light or dark, which goes back to my pen-and-ink days."

Here, in *Monhegan Light*, two men enjoy a sail in the waters around Monhegan Island, 17 miles off midcoast Maine. The wooden sailboat is heeled over in a brisk breeze, with the sail to the right and the people lining up on the left, framing the scene in a V shape. In the center of the V is Monhegan lighthouse, a visual counterpoint highlighted by intense white.

Conveying the cliff's height was a challenge. "I wanted to get that hit of golden light just off the top," the artist recalls. "It's awfully high up. If I were to do the whole cliff in sunlight, it would flatten out, and you wouldn't get the sense of looking up the hill." Instead, the darkened cliff serves as a foil for the boat.

Krupinski's paintings require a lot of preplanning. The first color that goes down usually is not the color she ends up with. The rooftops, for example, were done with scumbled light gray over darker gray. The inside of the boat was painted bright orange before being crosshatched with blue-black. Flecks of orange showing through the shadows add vitality. Most of the varnished wood areas, called brightwork, were achieved with underpainted orange, over-crosshatched with burnt sienna and burnt umber and glazed with rose madder or orange, depending on the light source. Likewise, dark-blue water might start out as bright phthalo blue, to be glazed later with blue-green or olive-green.

Krupinski has been working in color since 1982. She started in gouache, switching to oil five years later. Two events prompted the change: her move from Long Island to Old Lyme, Connecticut, in 1977, where she discovered the art colony's Impressionist painters, who were active from the early 1900s to around 1940 and included America's most famous Impressionist, Childe Hassam; and a 1980 trip to Mount Desert Island, Maine, where the dazzling light prompted her to begin seeing things in color.

These days she is working larger. "I can't see containing my work," the artist says. "I almost want to surround people with what I'm doing and draw them into the scene. In the future, I'll be getting more Impressionistic out toward the edges, while still keeping a sharp focal point, a combination I like very much."

THE LOBSTERMAN
18" x 12" (45.7 x 30.5 cm), pen and ink

Krupinski has carried the delicate cross-hatching technique of her pen-and-ink drawings, like this one, into color.

Krupinski established the basis for Monhegan Light *with this oil pastel sketch.*

Loretta Krupinski
WORKING FROM A PHOTOCOPY

Marblehead Dory was created from two different pictures taken at separate locations. Artist Loretta Krupinski photographed the window with seashells at Maine's Monhegan Island Lighthouse Museum; the dory was pulled up on the beach at Mystic Seaport, in Connecticut. Later, looking through a batch of pictures, she decided to combine the two.

Working from black-and-white photocopies allows Krupinski to delete unwanted objects with white paint, or to add more objects by drawing them in or cutting and pasting them on from other photos (taking care to adjust for perspective, of course). This method also gives her a sense of light and dark values without the confusion of color, and makes it easier for her to figure out water patterns and reflections, which become more discernable when viewed in black and white.

After photocopying both pictures, Krupinski cut out the windows from the museum image, taped the dory photocopy behind it, and then copied the combined images again. Using a proportion wheel, she enlarged the photocopy composite to 29 by 18 inches (73.7 by 45.7 cm). Next, she drew a grid over the original composite, starting with central horizontal and vertical lines, then halving the spaces again—the more detail in the pictures, the finer the grid must be. She then penciled a proportionally similar grid on her gessoed mahogany panel by selecting a point on the photocopy where the subject crossed the grid, repeating it on a larger scale, and continuing in this way until all of the combined scene was transferred and ready to paint. Finally, she erased the grid marks. "The process seems mechanical but it's very accurate," Krupinski says. "You grid a boat to make sure you'll get it right. Sheer line curves—the top edge of a hull—can be very misleading. *Never* trust your eye."

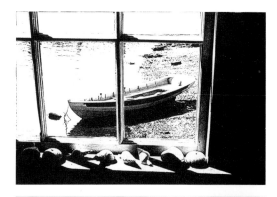

To convey the feeling of sunlight streaming through the window, the artist glazed a golden film of color over the already-painted shells and wall, aware of the way the light changed as it went around the curves. The sunstruck dory is defined by impressionistic light and color: yellow, orange, mauve, lime green. Its shadows were glazed and crosshatched with mauve over blues. The bow was sitting in just a few inches of water, which was lit by sunlight bouncing off the sand below. After painting this water an intense olive-green, Krupinski glazed over it with thin, translucent layers of orange and yellow, "so you get the sense of sunlight coming through." The deeper water beyond the boat is a mixture of ultramarine blue and cobalt blue, toned down with a bit of red used as a modifier. The same blue is picked up again in the boat's shadow, cast on the beach.

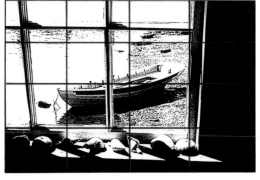

Working from a pair of photocopies, Krupinski used a grid process to create the composite image she wanted to paint.

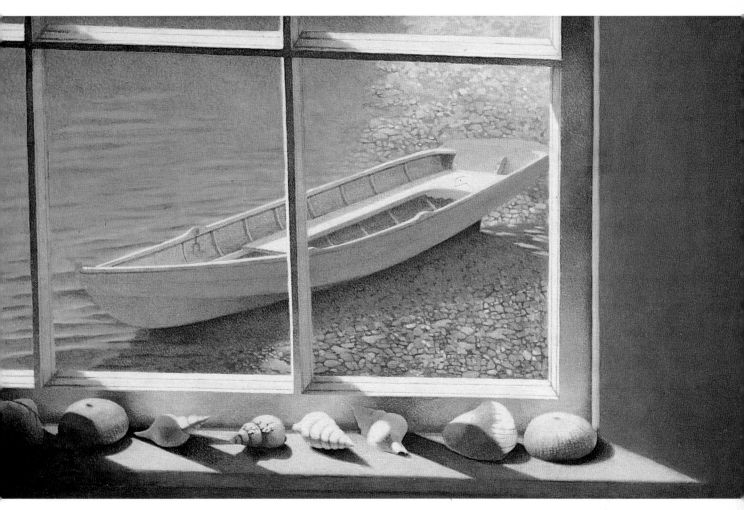

MARBLEHEAD DORY
29" x 18" (73.7 x 45.7 cm), oil, 1988

GETTING THE MOST FROM AERIAL PERSPECTIVE

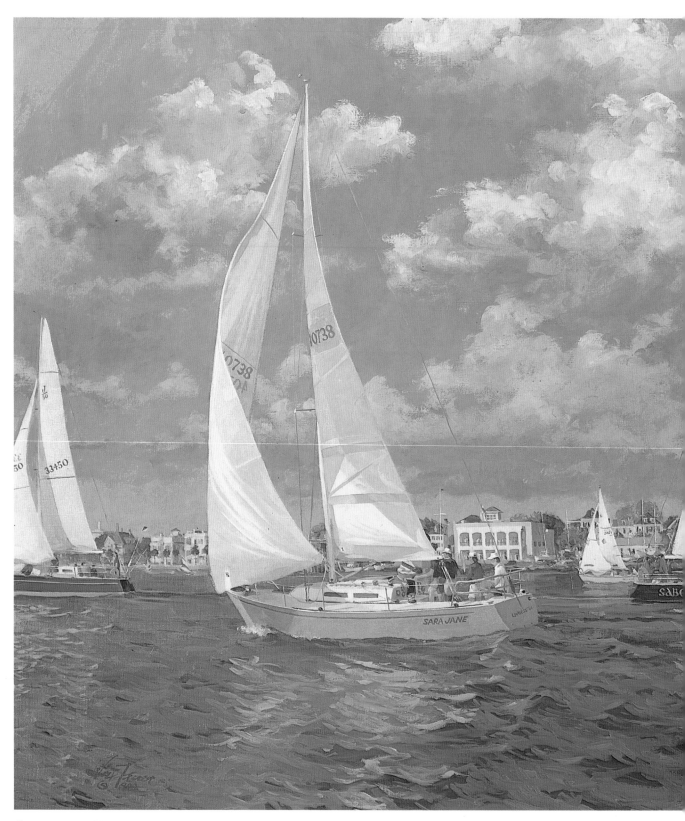

CHARLESTON HARBOR RACES
30" × 40" (76.2 × 101.6 cm), oil, 1988

The commission was a tough one: Capture the start of the Charleston Harbor races, which occur at midday. When the sun is highest in the sky, colors bleach out, shadows are at a minimum, and objects tend to flatten—not an optimum time for painting. How did colorist West Fraser make the most of what was essentially a blue-and-white scene? By avoiding white, for starters, and by taking full advantage of every variation and contrast he could find in shapes, sizes, and tones.

The translucent quality of today's high-tech Mylar sails added to the challenge. The fabric is almost blue-white, making strong value contrast (as one would have with bright white against blue) impossible, so the artist relied on color contrast instead. Employing the rules of aerial perspective, he brought the foreground whites forward with tints of yellows, and pushed the background whites away by adding purples and blues. "I don't think there's a single white straight out of the tube," Fraser notes. The "white" sail at the far right is really yellow-green, purple, and blue. Farther back, the *Sabeca*'s sails, a bit off the sun, are pearly white mixed with gray. Brightest is the Genoa jib of the *Sara Jane*, whose dynamic curve leads the eye into the painting. The boat's blue-white hull reflects the water; her sunny deck and toe rail, the sky. The boat's owner, who commissioned the painting, stands in the companionway, surveying the view. The blues in *Charleston* are also varied as much as possible. The sky gradates from left to right and from bottom to top, ranging from greenish blue to cerulean and ultramarine blue (also the colors of the water, by no small coincidence). Puffy clouds and water texture, with highlights, reflections and waves, contribute to the painting's energy. Flags and clothing gave Fraser the opportunity to add bright accents throughout.

In his quest for visual variety, the artist placed each boat on a different plane and assigned each set of sails a different shape. The random nature of the scene—vessels heading in every direction on different tacks, jockeying for position before the start of the race—adds a feeling of happy chaos. Boats entering and leaving the canvas convey a sense of speed. "Harbor scenes change so fast," says Fraser. "Ten minutes later, those boats will be gone and other boats will come along. I'm trying to create that sense of dynamic movement."

John Atwater
LEADING THE EYE

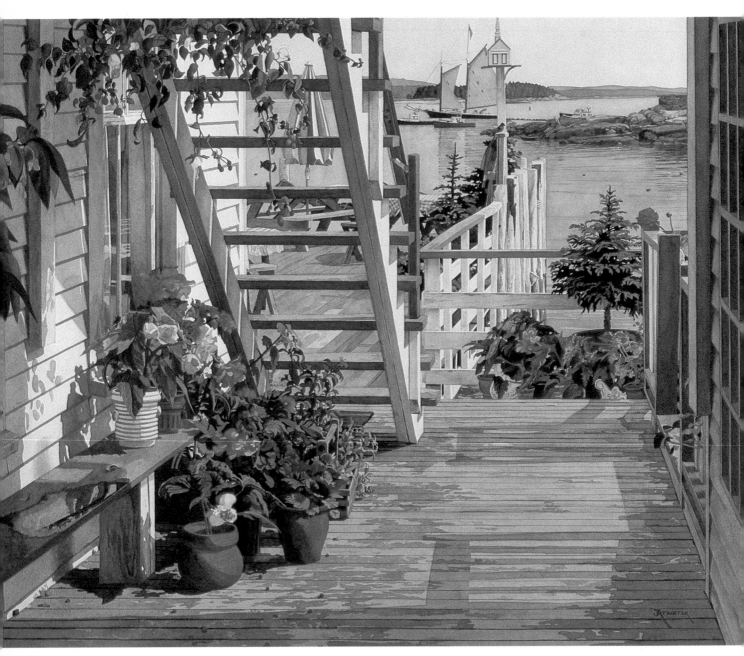

ENCHANTED
29¼" x 37½" (74.3 x 95.2 cm), watercolor, 1987

Exploring the coastal Maine village of Stonington one July afternoon, John Atwater happened to glance down a walkway leading to a deck overlooking the harbor and was enchanted by the view. Seen through a staircase in deep shade, the setting included bright flowers, an umbrella, a birdhouse, and a distant schooner passing by. "As soon as I saw it, I knew it would make a great painting," the artist recalls.

The scene was shot with several lenses and from many angles, bracketed to adjust for the wide range of darks and lights. Atwater then made a series of pencil drawings from the photographs, cropping and reframing until the desired perspective was achieved. Working from right to left, he covered the paper with washes, choosing colors even brighter than those in the actual scene. Early on, he knew the white clapboards and stairs would work as a foil for the other vibrant hues, and enhanced their brilliance by laying in a modulated wash of yellow, peach, and pink across the entire left third of the painting.

Atwater's watercolor technique is relatively dry and very controlled. For *Enchanted*, the process involved going back and forth, keying up, contrasting, and then balancing the various hues. At one point, the deck (mostly raw sienna) was two values lighter than the finished painting. "It was closer in value to the middle ground water and distant sky and landscape," he recalls. "The floor's light value didn't hold it down." So he added another layer of paint, after which the stairway "really popped out," and the floor became solid, completing the eye's journey from the foreground shadows through the middle ground's contrasting sunlight and shadow, to the distant light and hazy landscape.

One of Atwater's most important tools is a gray value scale, numbered one through ten—one represents black, ten is white—painted on a two-by-fifteen-inch (5.1-by-38.1-cm) strip of matt board. He uses the scale to assign relative values from color reference studies and photographs to the major areas of the painting, so that the finished work will have a consistent range. To prevent the palest areas from becoming washed out, Atwater uses values no lighter than nine. "Similarly, when I put the darks on, I want them to be a value of three or four," he explains, "but not so dark that they become flat." In *Enchanted*, the foreground blues—actually a gray composed of cerulean blue, ultramarine blue, cadmium red, and cadmium orange—are almost opaque, at a value of approximately 4.5. This color density provides a contrast to the lighter sunlit areas.

Final accents involved darkening the greens, and brightening the flowering begonias and hanging fuchsia. In the end, the viewer's eye moves between the bright, busy left foreground and the harbor scene at upper right.

The sailboat is the focus of attention, catching the viewer's eye despite the busy scene. Overlapping the boat behind the birdhouse helped to demonstrate the distance between the two.

Vern Broe
CONTRASTING VALUES

Vern Broe's paintings have a dreamlike quality—his boats seem to drift in a boundless sea. "The horizon is one of the strongest elements in a picture. It can work for you, or it can kill you." he says. "There's something about that line—it's like putting a face in a picture, it wants to take over. I've got enough to deal with, so I just leave it out." Even the water is defined by reflection only—an illusion, not really there. The artist's tendency to eliminate key elements while dramatically highlighting others comes close to pre-Renaissance Dutch painting. But in the end, the effect is uniquely Broe's.

Here, Broe chose to paint a pair of boats connected by light. He drew a full-size outline of the subject, scaled up from a tissue sketch with an opaque projector. The seamless background was achieved with a flat acrylic wash of umbers, ultramarine, and white on Masonite, sponged over with more thin washes to vary the tone.

Broe is more interested in contrasting values, the alternation of dark and light, than in colors. Looking for a dark value to play against the background, he settled on a phthalo-cyanine green for the sloop's hull. The other blocks of color were worked out from that: brown against white, white next to green, green against pale blue, pale blue next to brown. Each hue is further affected by the light source, resulting in highlights and shades. If he can avoid it, Broe is careful not to paint light tones over dark ones. Yellow ochre on top of sienna is "ugly as sin," he notes, although in the middle of the sloop he did apply ochre over dark green.

After laying in the green hull, Broe determined the painting's value range by adding the darkest darks and lightest lights—the skiff's stern and sails. He built up the color in five or six thin washes, handling the acrylic more like gouache. The sails started as off-white, followed by a wash of burnt umber, and topped by a wash of light cream, with a final wash of white along the edge.

For the rigging, the artist used a draftsman's triangle, holding his hand against its edge to direct the number 00 brush in a straight line. Each line is darker toward the end, for a more realistic effect, and some lines are darker than others, to indicate different planes. The looping lines connecting the boats were drawn freehand, and are influenced by the alternating light along their length: cream to brown, cream to brown. Broe is pleased with their rhythm, noting, "It's amazing how just a line will hold something down."

Broe feels that a long unbroken hull can be the "kiss of death." Here, he used a piling to break up the length of the sloop, "the way a bracelet breaks up the line of an arm." The pilings were handled the same way as the rest of the picture, with thin, light washes, followed by dark, then more light, then dark again, one on top of the other. The dark brown sections are a mixture of burnt sienna and burnt umber. The gray part is composed of successive washes of raw umber, burnt umber, and ivory black, mixed with white.

GREEN FRIENDSHIP SLOOP
28" x 42" (71.1 x 106.7 cm), acrylic, 1984

Vern Broe
THE ADVANTAGE OF SKETCHING

When painting a subject as unforgiving as boats, says artist Vern Broe, you've got to get the drawing right. And the only way to get it right is to practice. Broe spends hours making thumbnail sketches of boats in the harbor, or even sketching from magazine clips, trying to get a simple shape with just a few lines.

He usually sketches one boat, or two together, to redraw over and over, preferring to repeat the same shape rather than render many different ones. "It's like memorizing French, instead of picking up a smattering of French, German, Italian and Russian," he explains. "Learn one thing well. Memorize the hand gesture, so when you need it, it's there. Once you get a basic shape, it becomes part of your picture vocabulary."

The most difficult line to get right is the sheer line—the top edge of the hull. Drawing it correctly is the secret to a good-looking boat. Attention must also be paid to maintaining parallel curved lines, which can occur many times on a single vessel. As aids, Broe recommends using a draftsman's French curve or a set of marine curves, available at art and drafting supply stores, and through catalogs. For exercises, he suggests learning to draw a set of lines that will result in a skiff seen from the bow, from the stern, and from the side. Demonstrating with an on-the-spot doodle of a dory, Broe connects the bow and stern lines with a shallow S curve, then adds three quick vertical strokes to shape the sides.

Make up exercises, the artist suggests. What would happen if light came from the right? From the left? How would the change affect a boat's reflection? Describe boats by their shadows. Or play with values (darks and lights), keeping them in three solid blocks—top, side, and stern—rather than shaded gradations. Change the light source. Add another boat, and note how the two relate to each other in terms of light, shadow, and reflection. The variations are endless.

Drawing is important to this painter. The cabinets in Broe's Maine studio are filled with thousands of sheets, from thumbnails to finished drawings, in pencil, ink, and watercolor. Why does an accomplished artist still feel the need to brush up on basics? "Why not? Even a concert pianist still practices scales," he responds.

BROWN ROWBOAT
24" x 38" (61 x 96.5 cm), acrylic, 1983

THE ADVANTAGE OF SKETCHING

Boats are made up of compound planes that curve in two directions at the same time, "all of which gets very tricky," says Vern Broe. From certain angles, for example, a curved line on a hull will turn into a straight line on a drawing. To see this for yourself, Broe suggests cutting a wedge from an apple and looking at it from different angles. Or trace the lines of a rowboat from a photograph and compare them to those in the picture. "You'll get a real surprise," Broe notes, especially if the boat has lapstraking (sides made up of overlapping strips of wood). Then do a freehand drawing of it. "The moment of truth will arrive. 'This is going to take some figuring out!'"

Light and shadow can make all the difference. Without them, a stern-view drawing of a dory looks unbelievable. Particularly difficult is the stern of a Whitehall rowing boat, with its slanting "champagne-glass" shape. "Drawn in perspective, it can make you go crazy," says Broe. "It's a serious piece of work to get it to look symmetrical." A full mechanical perspective drawing is valuable for this particular subject, but usually such drawings are "a waste of time."

To draw boats realistically, an artist must first learn some basic principles, such as the difference between shade and shadow. Then find out how local color and local value interact with light and shadow, advises Broe.

John Atwater
AIRBRUSHING A FLAWLESS WATERCOLOR SKY

SHIPLEY POINT
19 ½" x 34" (49.5 x 86.4 cm),
watercolor, 1988

Easing into a coastal harbor at the end of a perfect summer day—winter-weary sailors dream of such peaceful scenes. Here a schooner has passed Shipley Point and is heading for Christmas Cove, a midcoast Maine sailing mecca. Artist John Atwater recalls being inspired by the atmosphere: "The sky was the palest blue and rose, with rose infusing the colors of the water and landscape as well." He added the schooner as an afterthought.

To achieve the sky's clarity, Atwater used an airbrush, holding it about two feet (61cm) from the surface and sweeping it across the paper as many as 100 times, applying color very slowly in a smooth, even manner that would have been impossible with a paintbrush. The color of the sky at its zenith is a pale cerulean-aquamarine bluish gray. The rosy haze near the horizon reflects the light from the sunset in the western sky. To harmonize landscape with sky, the artist added peaches and pinks to the rocks and wild roses, and warmed the greens of the background trees. He infused the blue sea with warm rose tones by washing in some alizarin and cadmium red, applied in two or three thin, almost dry, layers. As he worked, he covered the finished sky with acetate to prevent waterspots, which would have bled into the airbrushed background and left a ring.

The boat was photographed during a midday race, but Atwater adjusted the direction of light across its sails to suggest an end-of-day context. He painted the sail shadows a light raw sienna tone to retain the sense of glowing translucent light, although, in reality, such details would have been lost at just a few minutes before sunset.

The extraordinary light and atmosphere in Atwater's paintings derive from three sources: Photographs help the artist capture a specific time of day, especially at dawn and dusk, when light changes rapidly; in addition, he has studied the color values and palettes used by artists of the nineteenth-century Hudson River and Luminist schools, even making oil pastel color studies of their museum works; finally, he clips reproductions of appealing scenes from books and magazines. "The lighting of a scene entails capturing the effect of a certain color of light, so that all the objects in a painting, while exhibiting their own local color, are modulated by the color of the atmosphere," he explains. In *Shipley Point*, the entire landscape assumes a warm, rosy glow, reflecting the light of the setting sun.

Thread of Life *was inspired by "the color of light," says Atwater—peach and rose above bright cerulean blue. The sky was airbrushed, gradating light to darker toward the horizon, where he added a band of rosy haze. The pale-blue fog at the horizon serves to highlight the boats, which were added last as subtle points of interest.*

THREAD OF LIFE
22¼" x 34" (56.5 x 86.4 cm), watercolor, 1987

Working the Sea

Loretta Krupinski
USING NEGATIVE SPACE

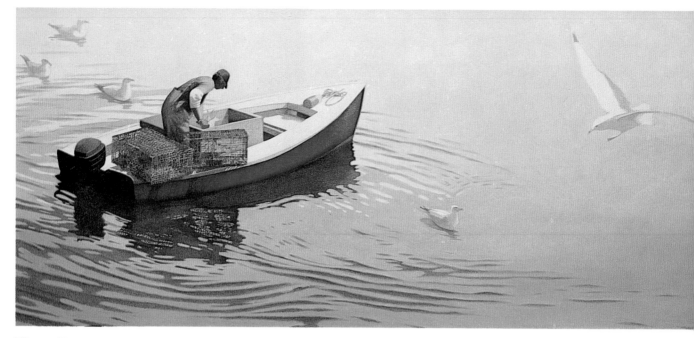

WATER BALLET
41" x 19" (104.1 x 48.3 cm), oil, 1989

"I'm very interested in working with composition, getting unusual angles and seeing things that other people don't see—like that painting over there," says Loretta Krupinski, gesturing toward *Water Ballet*, a scene of a lobsterman in his dory surrounded by a flurry of gulls. The picture, newly completed and as yet unframed, leans against a wall of the living room in the summer cottage Krupinski has rented in New Harbor, Maine.

Water Ballet has unusual proportions, with a length-to-height ratio of more than two-to-one. Krupinski was attracted to the scene by what was happening to the water—the pattern of ripples and their reflections expanding outward to a peaceful calm. It was the contrast in textures that prompted her to extend the scene to the right, well beyond what her photographs indicated. There, the placement of a lone gull creates dynamic tension, forcing the viewer's eye from bird to boat and back again, and demonstrating how broad areas of negative space can be used to divert attention and suggest motion.

Krupinski began by laying in a warm greenish-gray tone, gradating from dark to light. This background set the mood for the boat, which was blocked in next, followed by the motor, man, and lobster traps. The traps initially seemed rather lost in an ochre color, so she strengthened them by creating darker areas of deep browns and blues inside, and by retaining the patterns of the mesh. "If you are losing the shape of an object, it's because you haven't brought in enough darks," the artist explains.

Krupinski worked hard at achieving the correct color values in the reflections, until the light was doing "wonderful things." To attain this effect, she glazed orange into the curls and softened the edges toward the viewer, meanwhile darkening the little edges at the top of each reflection by glazing and cross-hatching. Jolts of color here and there, such as the hit of blue in the motor's reflection, the play of deep green and oranges in the boat reflection, and the blue-purple in the shadows, provide variety and surprises.

Seagulls give any marine painting character, but for Krupinski a few go a long way—she adds them only if they are relevant to the scene. The wire traps are part of a changing heritage. "Three years ago, they used wooden ones. In 50 years, we may not see mesh traps," she says. "We may not even have boats that look like this. Who knows?"

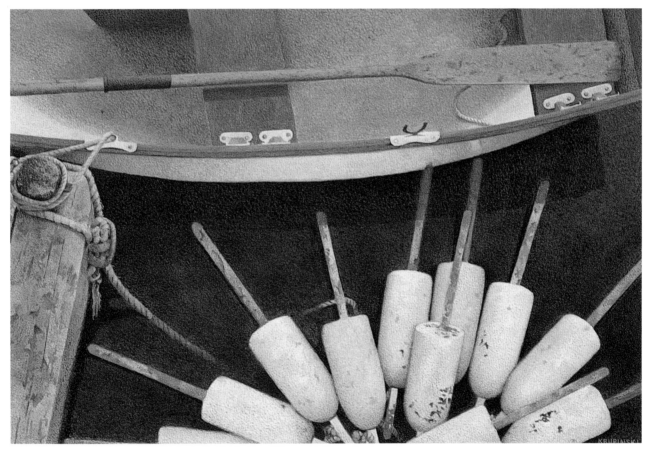

MAINE POPSICLES
20" x 13 ½" (50.8 x 34.3 cm), acrylic, 1986

The strong positive and negative shapes created by this fan of lobster buoys, dinghy, and dock caught Krupinski's eye.

Joseph A. Wilhelm
PAINTING MARINE MINIATURES

Before he became a painter, Joe Wilhelm was a professional ship model maker, accustomed to working on a scale of 1 to 1,200. Expanding his repertoire to include miniature oils—which for Wilhelm means anything nine by twelve inches (22.9 by 30.5 cm) and under—was a natural. But just because the paintings are small doesn't mean they lack detail: Water pours out of tiny scuppers; one tug sports pinpoint running lights; another flies an American flag an eighth of an inch (3 mm) square; and the name on the bow of the *John L. Sullivan* is less than one-sixteenth of an inch (2 mm) high.

Wilhelm uses a Winsor-Newton number 3A sable round brush for most of the work, switching to a 670 Langnickel number 1 for the rigging, rails, and other details. The miniatures are painted on Masonite, with three coats of gesso brushed on horizontally, vertically, then horizontally again.

Like the silks of a racing stable, each tug company has its own set of colors, and Wilhelm knows them all. Model builders and artists write to him from around the world, requesting color schemes. The housing of the *A.J. Higgins*—a tug used for pushing barges on the Mississippi—is

Venetian red, mixed with cadmium red medium. The housing of the *Alma S*, a New Orleans ship-handling tug, is made up of yellow ochre and cadmium yellow, with some alizarin crimson and ultramarine blue mixed for the white, and venetian red, cadmium red light, and ultramarine for the shadows. The *John L. Sullivan*'s housing is a combination of yellow ochre and raw umber. And for the *A.W. Whiteman*, Wilhelm painted the water, both fore and aft, with various combinations of ultramarine blue, alizarin crimson, and raw sienna, adding a bit of burnt umber in the wake and thereby playing cools against warms for a nice effect.

Wilhelm began painting in 1975, when he was 51. He has never had a lesson, and his only concession to age is a pair of prescription glasses with magnification set at 11 to 15 inches, so that he can work up close for hours at a stretch without headaches. Throughout the years, miniatures have remained a favorite theme. "I love to do these small ones," he says. "Some I'm really sorry to sell." When asked how long they take to complete, he replies, "Three hours—and 16 years."

A.J. HIGGINS
4" x 5" (10.2 x 12.7 cm), oil, 1988

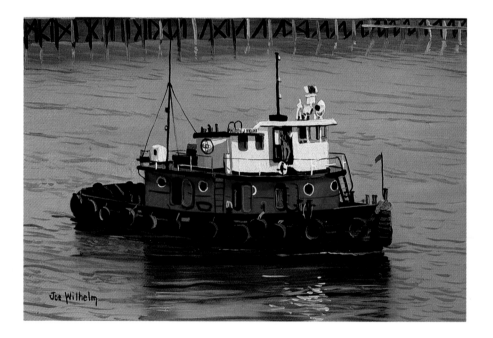

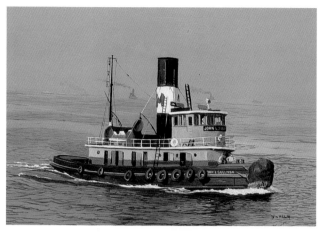

JOHN L. SULLIVAN
5" x 7" (12.7 x 17.8 cm), oil, 1990

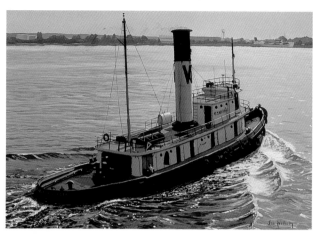

A.W. WHITEMAN
5" x 7" (12.7 x 17.8 cm), oil, 1989

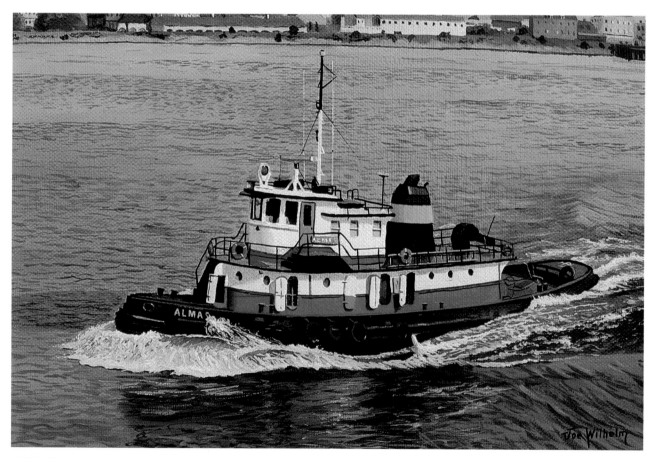

ALMA S
9" x 12" (22.9 x 30.5 cm), oil, 1988

Thomas M. Hoyne III
USING SPLIT PERSPECTIVES

Launching a string of dories from a fast-moving fishing schooner in rough seas could be dicey. More than one fisherman likened the experience to jumping off a racing freight train. Each boat was swung over the rail with one man in and the other ready to join him. Then the dory would be winched down until it was just above the waves, and cast off. A string of dories launched one after another in this manner was called a *flying set*. After the last dory had been dropped, the schooner returned to pick up the first boat again, which by then had set her trawl and marker buoys. One by one, the dories were either hoisted back on deck or towed astern in sequence, giving the men time for a "mug-up" of coffee as the baited hooks caught the fish. Then they returned for the haul.

Artist Tom Hoyne's split perspective—half deck, half sea—puts the viewer right in the action. The setting is almost palpable—it's dawn and a good swell is running, with a chop. "I saw this one almost finished," says the late artist's friend Charles Kessler, referring to *A Flying Set*. "Tom fooled with the water quite a bit, scraping off some parts and doing them again. It got too thick, or too light, or too dark, and he'd be unhappy with it. There was a lot of angst. He was a great worrier, you know."

A Flying Set was painted in combinations of earth tones, Naples yellow, raw umber, and Mars yellow. The artist posed for at least two of the figures himself, dressed in oilskins. The wet, reflective surface adds interest to the deck.

Hoyne never worked before a conventional easel, preferring to sit at an electrically tilted drawing board instead. A piece of plate glass served as a palette, with the colors laid around the perimeter and a sheet of 20-Below freezer paper taped to the center. He used the paper as a mixing surface, and at the end of the day simply untaped and discarded it.

From extensive reading, Hoyne learned how fishing ships were rigged, dories launched and retrieved, fish transferred and stored on board, and what a fisherman's life at sea was like. He also collected maps, charts, and coastline scenes for ready reference. A tour of the Pacific during World War II gave him additional firsthand knowledge of the power and action of the sea.

His wife Doris, a librarian, helped him compile a card file on more than 5,000 fishing schooners, each listing the history of the vessel, book and photo sources, and personal contacts with writers, ship builders and owners, model builders, curators, sailors, and former fishermen. From these resources, the artist created more than 100 marine paintings from 1978 to 1989, a steady rate of about ten per year.

Hoyne believed that Gloucester fishing captains were the greatest mariners in the world. "Without diplomas, without engines, without modern navigation equipment, they took their vessels to all parts of the North Atlantic fishing grounds and back," he said. "Notwithstanding, losses of life and vessels were tremendous, due to accidents and weather. It was a dangerous life for all, battling the sea and the elements."

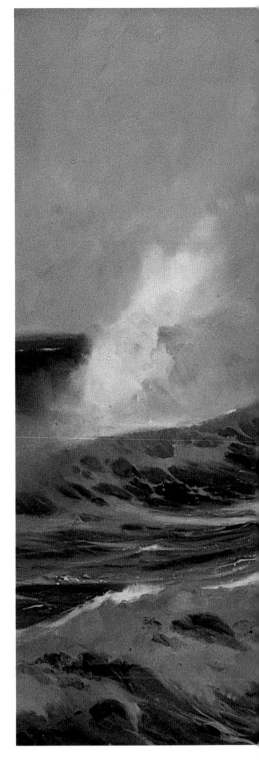

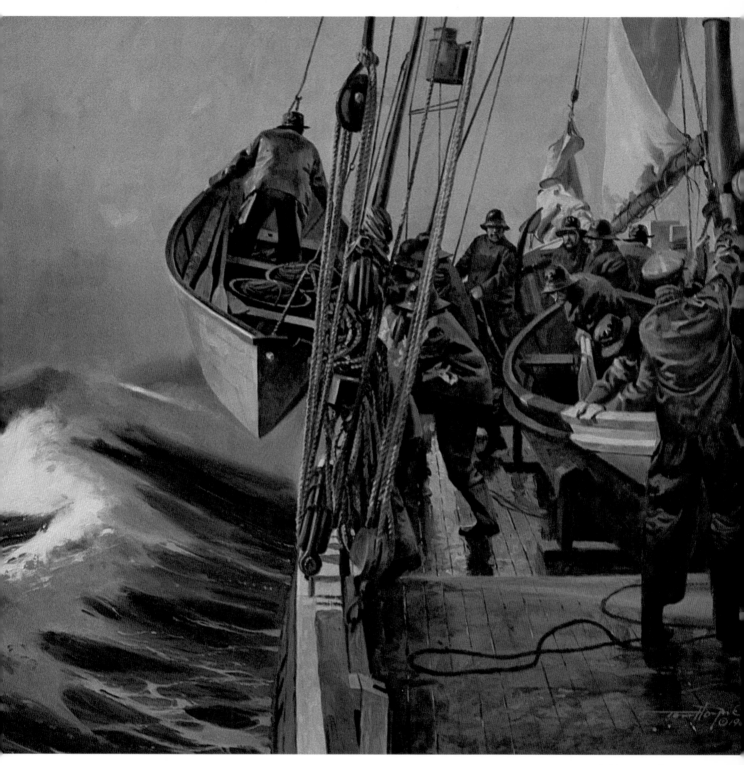

A FLYING SET
26" x 38" (66 x 96.5 cm), oil, 1988

Thomas M. Hoyne III and Erik A. R. Ronnberg, Jr.
PAINTING FROM SHIP MODELS

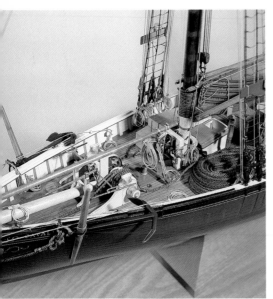

PHOTO: ERIK A. R. RONNBERG, JR.

Fore deck detail of the fishing schooner model Cavalier, *which dates to 1904, shows the large anchors, windlass, and hemp cable schooners required when anchoring on the banks to fish.*

A collaboration between renowned marine artist Tom Hoyne and the equally respected ship model maker Erik A. R. Ronnberg, Jr., of Rockport, Massachusetts, has resulted in a unique collection of fishing schooners and a trawler, dating from the 1880s to the early 1900s. Hoyne commissioned the models—each about four feet (1.2 meters) long, on a scale of 1 to 32—to aid him in his paintings, posing each vessel in a sandbox to simulate waves. Ronnberg equipped several of them with two or more kinds of fishing gear, so the artist could represent different types of fishing in various paintings. "All parts work," Hoyne once said. "The blocks run, the windlasses crank, the anchor chain comes in and out. They're probably the only models of their type in the country."

The only thing missing on these elegant models were the sails. "Tom felt he could do a better job of painting sails by eye than he could trying to deal with cloth sails," Ronnberg explains. "Even in that larger scale, sailcloth is too bulky and intractable to set realistically on a model." Instead, depending on the wind conditions he wanted to portray, Hoyne would set the movable booms and gaffs in their proper positions and let his imagination trim the canvas, either fully set or reefed down.

The larger models took Ronnberg about 1,000 hours apiece to build, with stacks of dories, seine boats, and fishing equipment adding another 200 to 500 hours to the work. He used well-seasoned native poplar for the hulls. Decks and bulwarks were made of basswood and holly, with birch and lancewood for the spars. Most of the brass hardware he machine-tooled himself, assembling the fittings with miniature rivets or threaded bolts and nuts. Rigging was made of either stainless-steel wire or linen cordage. The models are accurate even in such nuances as the styling of the ironwork and wood moldings, proper rope splices, and the visual effects of weathering and wear.

Ronnberg, editor of the *Nautical Research Journal* (a Maryland-based quarterly concerned with nautical history and ship modeling) and former curator of the New Bedford Whaling Museum, has been a professional ship–model maker since 1966. He crafted his first model at age six, encouraged by his father, who was a ship rigger. Today his work may be seen at the Smithsonian Institution in Washington, D.C., the Plimoth Plantation in Massachusetts (where Ronnberg built the replica of *Mayflower II)* and the Mystic Seaport Museum in Mystic, Connecticut, permanent home to the Thomas M. Hoyne Fishing Schooner Collection.

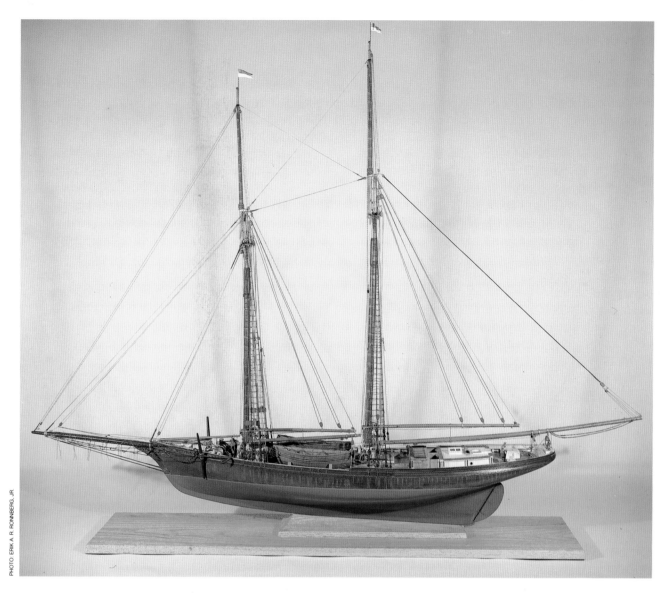

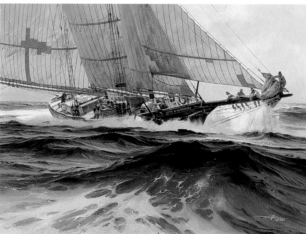

The Fredonia-*type fishing schooner* Senator Lodge *(above), built in 1893, was the posing model for Hoyne's painting* First Life *(left), which is also shown on page 81.*

FIRST LIFE
27" x 36" (68.6 x 91.4 cm), oil, 1984

Joseph A. Wilhelm
USING A FAN BRUSH

Joe Wilhelm is a steamship artist—liners, cargos, warships, and tugs his specialty. He is also a man obsessed: "Any kind of steamship or motorship, that's all I ever looked at, or cared about," he says, with a soft New Orleans drawl. "If I didn't have that, I don't know what I'd be interested in. It really makes life worth living."

Tugs are Wilhelm's favorites. Many times he boarded the *Humrick*, a big ship-handling tug that plied the Mississippi River in the late 1960s. It was owned by a boyhood friend of his, who offered Wilhelm the medallion from her stack as a memento, an offer the artist sadly declined, realizing he would need an 18-wheeler to cart the prize away. Instead, he painted the tug's picture. "She was a great favorite of mine," he comments. "One of the best looking tugs I've ever seen."

For Wilhelm, the most influential part of a painting is the sky, which he paints first. He employs a broad palette of sky colors, including violet, rose, deep magenta, brilliant yellow-green, and manganese blue (an airy greenish blue of which he's particularly fond). Here, he applied mixes of titanium white, ultramarine blue, yellow ochre, and alizarin crimson in patterns, and then softly fanned them together.

The colors that make **up** the water—primarily phthalo blue and raw umber with highlights—were also applied with a fan brush. Light areas were laid in where dark waves were planned, and darker passages where the artist wanted small light ripples, and the two were then blended together. "I always put a color in with the idea of what will come on top of it," the artist explains. Wilhelm lays out as many as 30 synthetic white sable fans at a time, making just a few strokes with each until it gets soiled and begins to streak. Then he picks up a new brush and works in the opposite direction to remove the streaks. Keep the blending to a minimum he advises—every time paint is touched with a brush, it dulls.

When finished with a brush, the artist swishes it in mineral spirits and sets it in a jar filled with detergent. At the end of the day, stiff brushes are cleaned by agitating them in two separate baths of detergent and hot water. Fine-haired brushes are cleaned with Nivea oil moisturizer ("Great for hands but what a paint remover!"). Wilhelm will

also use Winsor-Newton Artgel, and SAE 10W-30 motor oil. "I thought my artist friends were crazy when they first told me about the motor oil," he says, "but it works very well."

The *Humrick*'s buff pink housing—a mix of white, raw umber, Naples yellow, alizarin crimson, yellow ochre, and cadmium yellow light—was a difficult color to achieve. It took three coats to capture the glint of late afternoon sun on the pilot house, and more time to render the lights and shadows on the "bonged out" section along the side of the deckhouse, which had stretched and rippled under stress. The hull was painted Mars black, toned with blue and browns and cut with white.

Using a large color print of his own photograph for reference, Wilhelm drew the tug on the canvas freehand, in black India ink, then added tonal washes.

He gave the surface a washcoat of oil, to eliminate the white and establish the values, and then blocked in the sky, trees, and tanks with opaques.

Next, he blocked in boat and water, further delineated the background, and began to lay in the lights and shadow (left). The addition of such details as handrails and water action completed the work (below).

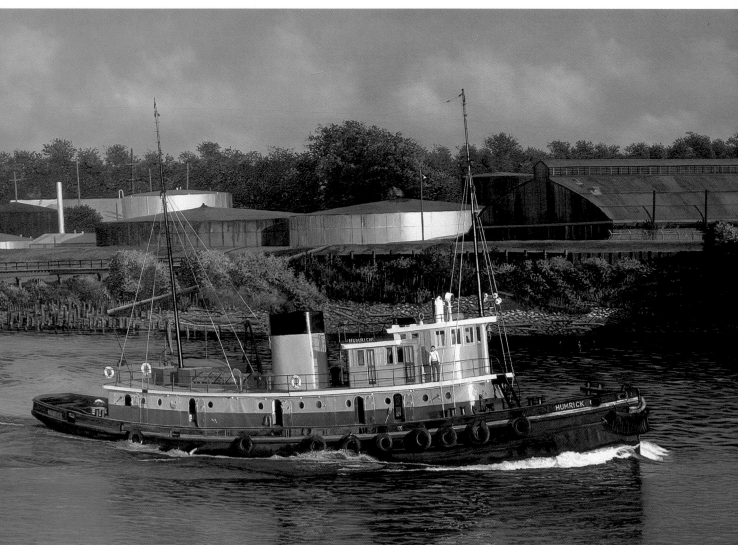

HUMRICK
24" x 30" (61 x 76.2 cm), oil, 1989

Keith Shackleton
EFFECTIVE USE OF GRAYS

Contemporary artists should paint the contemporary scene as experienced in their daily lives, advises Keith Shackleton. Not that there should be fewer tea-clippers, or Drakes rounding the Horn—just more supertankers, roll-on–roll-off ferries, and oil rigs.

The artist had the chance to make good on his word when Shell Expro commissioned him to paint one of its oil rigs in the North Sea. "It was a lovely thing to work on," recalls Shackleton in his book *Wildlife and Wilderness: An Artist's World.* "The North Sea in winter is a comfortless place, but the rigs were all warmth, strict discipline and an all-around feeling of competence and technical expertise. Nobody spared any effort, especially the helicopter pilots who would sit about just above the waves while I drew things, for as long as I liked. Shell had made no strictures in their brief, just the atmosphere and of course—the rig."

The artist lived on the rig *Brent Charlie* but came to appreciate *Brent Bravo* for her mammoth dimensions and the cut of her jib. "And so it is she is in the painting, standing there like a vast Aladdin's lamp on elephantine legs, straight out of the ocean," he writes. Below it, the 130-foot service vessel is dwarfed in the pounding sea.

Shackleton drew the ship using reference plans sent by the company, but he worked out the angle he wanted himself. The grays that convey the brooding atmosphere are the same for sky, rig, and sea, achieved by various mixes of cobalt blue, cadmium orange, and a touch of ivory black. The background was laid in first, then the sea, where both lighter and darker gray tones add variety. Against that deadpan ground, the vessel's bright cadmium orange hull stands out. Shadows on the side of the boat were indicated with brown pink, a transparent pigment made by the British firm Robeson and Rowney. Despite its name, the hue is neither brown nor pink, but when thinned becomes a color similar to Scotch whisky. "Mixed with other colors, it produces a darker shadow tone without actually changing the color itself," notes the artist, who uses a bit of the pigment in every painting.

Helicopter's-view sketches, like this one of the accommodation platform Brent Charlie, *were discarded in favor of a much lower-angled view and the* Brent Bravo *rig, with its more appealingly angled flare tower.*

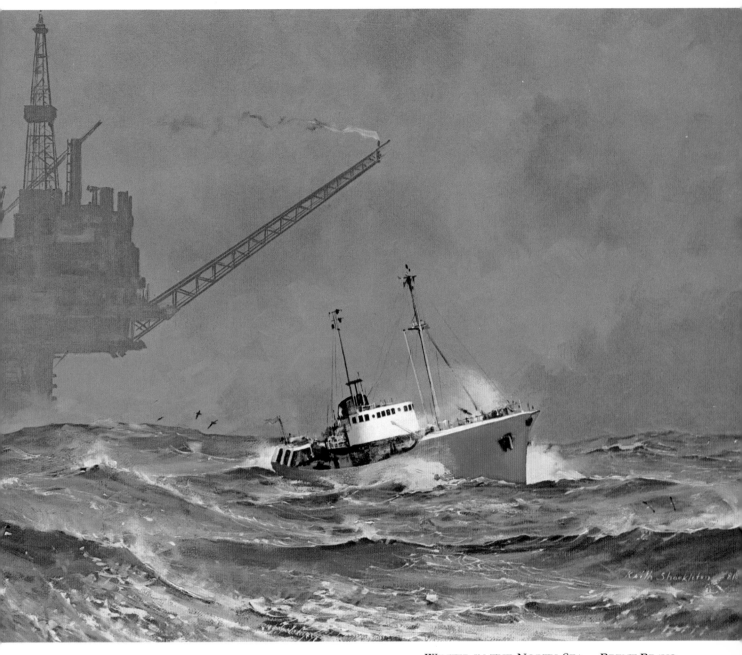

WINTER IN THE NORTH SEA—*BRENT BRAVO*
18" x 30" (45.7 x 76.2 cm), oil, 1984

James E. Mitchell

ENLIVENING PAINTINGS WITH A STORY LINE

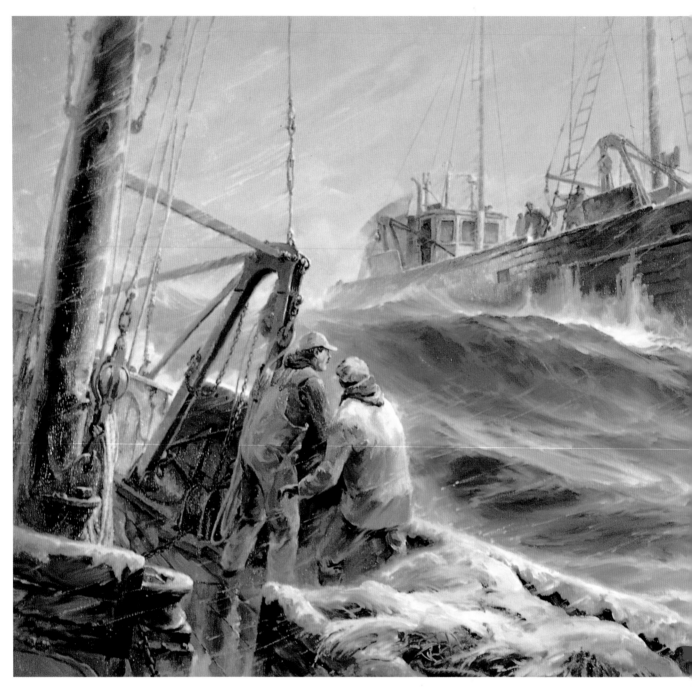

A WINTER'S GAM ON THE GEORGES BANK
27" x 40" (68.6 x 101.6 cm), oil, 1985

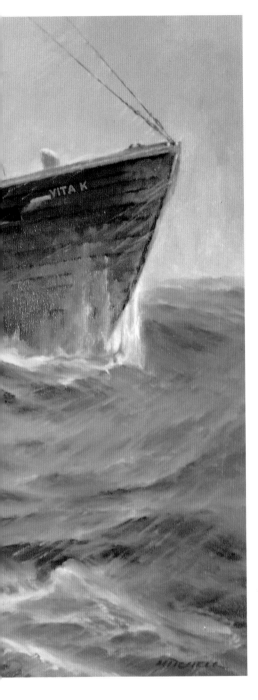

Trawlers are today's fishing schooners, yet too few marine artists bother to paint modern maritime scenes, favoring instead the more elegant Gloucester and Lunenberg schooners from the last century, a situation Jim Mitchell finds unfortunate. "Everybody and his brother paints Gloucester schooners or the square-rigged sail era these days," he says. "Too many artists in the marine field overlook documenting that world around them, which is rapidly disappearing. It irks me no end."

The vessels shown here are wooden-hull Eastern-rig side draggers, still in use but being replaced by steel Western-rig stern draggers—"nasty-looking things that can catch a lot more fish but are not nearly as seaworthy as these old babies were," Mitchell notes. The artist keeps an eye on trawlers in the harbor a half block from his home in Newport, Rhode Island, painting favorites for appreciative collectors.

In this case, he set out to document the *Vita K*, the trawler in the background—built in the 1940s, and the last of the schooner-hull type still operating out of Newport. It was difficult to decide which feature to emphasize—her lovely hull sheer, with its prominently raked bow, or the "champagne-glass" transom. Eventually, he opted for the bow view, shown here rising out of the sea.

Tired of painting "ghost" ships with nobody on deck, the artist decided to illustrate a story line as well as the ship itself. The trawlers have stopped for a gam, a seaman's term for a friendly exchange of news about families and fishing. The *Vita K*, heading home, has paused, with the sea coming from astern. The near boat, about to fish on the Georges Bank, approximately 160 miles out from her home port in Newport, is hove-to, holding her position with her engine turning just enough to keep her head to the wind. Ice covers the nets and bait boxes on deck, and the men hang onto icy shrouds and stays as sleet streaks across the scene. "We're looking at a place where I'd hate to be," says Mitchell, a former seaman himself. "I know—I've been there. It's cold and it hurts." The figures give the boats life.

Mitchell made eight thumbnail sketches, including this one, which he later rejected in favor of the more dramatic action of the sharply raked schooner bow dominating the picture area.

Joseph A. Wilhelm
THE PROCEDURE FOR PAINTING A SHIP

When painting ships, everything has a sequence. For artist Joe Wilhelm, this portrait of the British liner *Queen Elizabeth*, on Masonite, began with laying in the sky and landscape—a New Jersey scene. Next he gave the larger dark areas of the ship a coat of Mars black to establish form, and roughed in the water, a mixture of indigo blue and raw umber. "At this point, it could be any dark color," Wilhelm notes. "I just wanted to get the white surface off the board."

On the second pass, he went back over the hull, this time painting it a rich black consisting of Prussian blue and its complement, orangy Venetian red. The ship's superstructure received a coat of white, with a touch of raw umber added for highlights and ultramarine blue for the shadows. At this point, Wilhelm paused to correct perspective, using a plastic triangle to ensure that the verticals were straight up and down. Getting the red and white band below the hull to be smooth and the curve on the promenade deck to be correct can be especially difficult, he notes.

Next came the funnels, Wilhelm's favorite part of any ship, which received a coat of Liquitex scarlet—"the exact color of the Cunard line"—with greens and browns added for shadows. Then came the lifeboats, a repetitive task the artist dreads. "There are so many of them on a liner like this," he says. "Diminishing perspective must be kept in mind, and the color lightens as they get further away. It's difficult to approach boat no. 9 with the same state of mind as the first one."

Going over the painting for the third time, Wilhelm gave the *QE*'s superstructure its final light and shadow. On the bridge front facing the sun, the wooden decks reflect light upward, making the lower part of the ship's "face" somewhat more yellow than the upper area. Masts and booms were added next—light buff on the sunny side, a darker value in the shade—followed by the rigging, stern to bow. To paint lines thinner than a hair, Wilhelm uses a 670 Langnickel brush number 1. "It's long, thin, comes to a point like a needle, and holds enough paint to draw a line a foot long," he says.

Next, the artist completed the lifeboats, meticulously adding a dab of light to each bow, brushed darker toward the stern, and a dab of dark at each one's base, fanned to blend. To finish the water, including reflections, he started with ultramarine blue, yellow ochre, and alizarin crimson, eventually adding raw umber, scarlet red, phthalo green, chrome-oxide green and light red before he was through. After it dried, he put in the white wake of the tugs and the gulls. "It's a feel-your-way process," says Wilhelm. "The painting is wet and the colors will work into each other to give unexpected combinations. There is no formula." If all is still going well at this point, the artist signs his name as soon as the water is dry and he's certain that "I know I'm not going to have an emotional explosion and throw the thing in the trash, or pop it over my knee."

The tugs came next. Wilhelm had laid in the bases of their hulls before he painted the water, so the water could be brought up to them, making them appear to be floating. Then came the final details—rails, figures, and flags. The crew were positioned in their proper places, including a lookout at the bow and sailors on the fore deck, ready to handle the lines from the tugs. Flag details are also important to get right, the artist notes: Three flags fly from the mainmast area. The British flag is shown reversed—blue with a red box—meaning that her officers belong to the British Naval Reserve. The two house flags signify ownership by the Cunard White Star Line. The American flag, at the top of the foremast, indicates that the ship is in an American port. The white and red flag on the yardarm shows that a Port of New York pilot is aboard.

To make this painting, which took five days to complete, Wilhelm relied on his considerable knowledge of ships, plus color photographs, flag books, and plans of the *Queen Elizabeth*. Even so, something went awry. Originally, the painting had been titled *Sailing Day*, which is how it appeared as the centerfold in the prestigious British magazine *Seabreeze*. Soon Wilhelm began receiving letters from "ship lovers nuttier than I am," informing him that the *QE* was actually arriving, not sailing out, in his depiction. Certain flag symbols and the position of the tugs gave it away. Says the artist, "Sometimes, you can't win for trying."

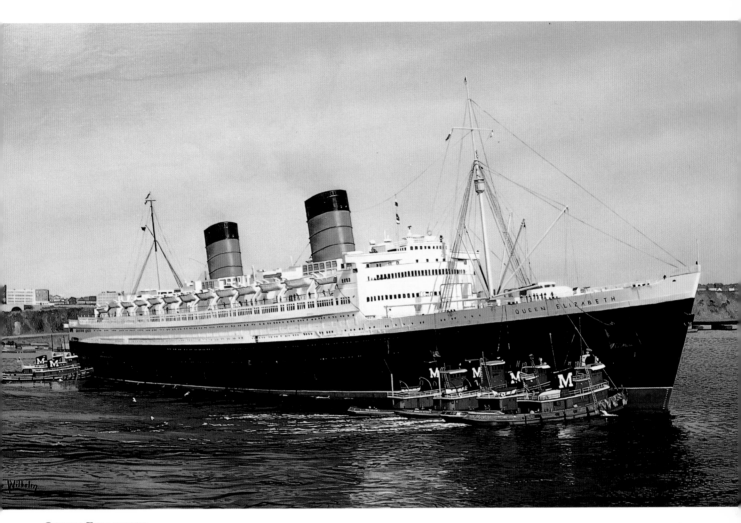

QUEEN ELIZABETH
16" x 24" (40.6 x 61 cm), oil, 1987

Keith Shackleton
CAPTURING ICY SOLITUDE

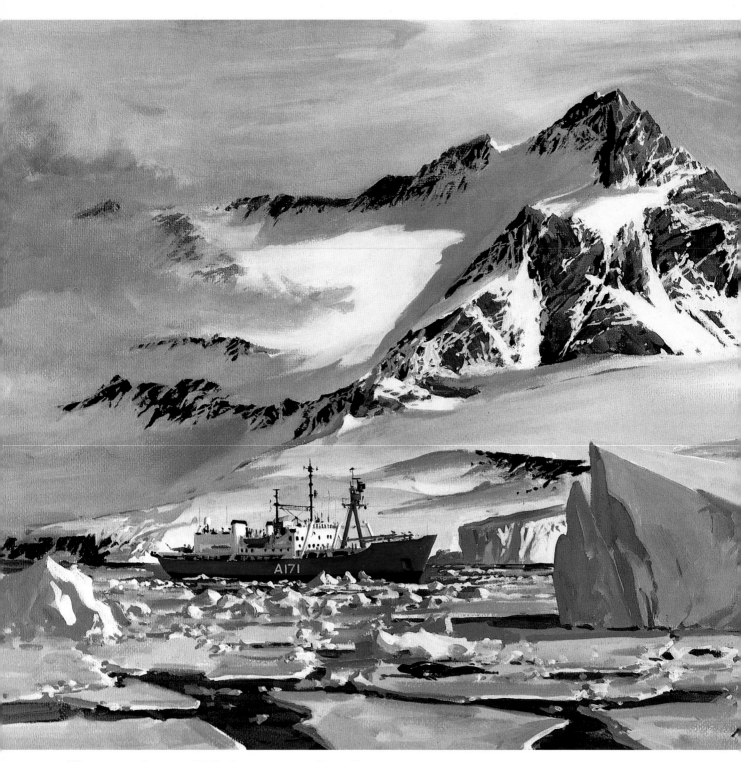

WILDERNESS PATROL: HMS *ENDURANCE* AT HOPE BAY
18" x 24" (45.7 x 61 cm), oil, 1982

The HMS *Endurance*, a British ice-patrol vessel for the Royal Navy, excites pride and affection even from those who never served in her, notes British artist Keith Shackleton. Based in the Falklands, the *Endurance* performs communications services, provisioning, and mail delivery for all the nations with scientific bases in Antarctica. According to Shackleton, it was the ship's withdrawal from her home base in 1983 that triggered the invasion of the Falklands by the Argentines, who believed England had lost interest in protecting its territories in the South Atlantic. The performance of the *Endurance* in the skirmish served to further bolster her fan club.

Shackleton has voyaged often to Antarctica as a naturalist aboard the adventure ship *Lindblad Explorer*. Upon accepting the commission to paint *Endurance*, he admits, "I was more interested in the place where she worked than the ship herself." Dominating the scene is Mount Flora, "a lovely scramble of a climb, littered with fossils." On the right is the foot of Depot Glacier—in reality located a few miles farther south. Rearranging the topography to satisfy his aesthetic whim troubles Shackleton not a bit. "I cannot see it as playing God to move a few billion tons of ice a few miles north with my little hog-hair brush, if that is where I would like to see it," he reasons, invoking the prerogative of painters everywhere. "It's the atmosphere that was wanted, rather than an actual record of the place itself."

Shackleton began by establishing the horizon line, then determined the position of the vessel and its degree of prominence, making it as small as he dared. To convey the deep blue of the large iceberg, the artist chose electric-bright Antwerp blue, "the most useful ice color." He also uses indigo—the color of dead ink—and "fierce" Winsor blue for this purpose. A touch of alizarin crimson or cadmium orange cuts the cold a bit and lessens its intensity, if that is what the subject demands.

"It is the very whiteness of ice that strikes contrasts with all around it—sky, water and rock," the artist notes. "Yet white, by its very nature, reflects something of the colors around it. Only in its deepest and most sheltered recesses can be seen the brilliant blues that are all its own." Shackleton uses titanium White, which darkens less with age than paints based on lead oxides.

The artist paints on Masonite, using rough surface boards that he covers with Polyfilla, the British version of spackle, applied with a squeegee. When the board is dry, he sands it down and adds a coat of priming paint. The surface ends up like canvas but is much better to paint on and "more durable for throwing in and out of small boats and Land Rovers," the artist explains. Further advantages: If a composition becomes too lopsided or top-heavy, an inch or two may be sawed off to restore the visual harmony, and pictures doomed to failure can be rubbed down with a power sanding machine for another try.

Here, the *Endurance* makes her way through ice-filled Hope Bay, her vermilion hull the only bright spot in a frozen land. Although Shackleton enjoys tropical climes, such icy vistas remain his favorites. "When it comes to painting, and the visual motivation a subject exerts, the ice surpasses everything," he remarks. "The ice and, of course, the sea."

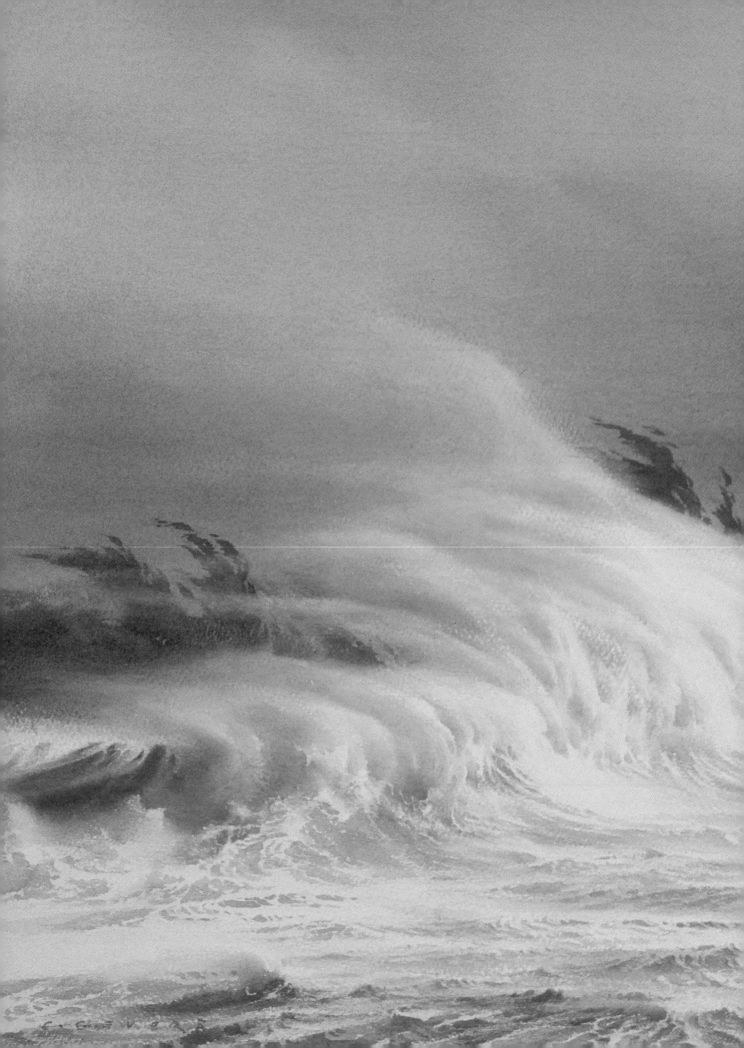

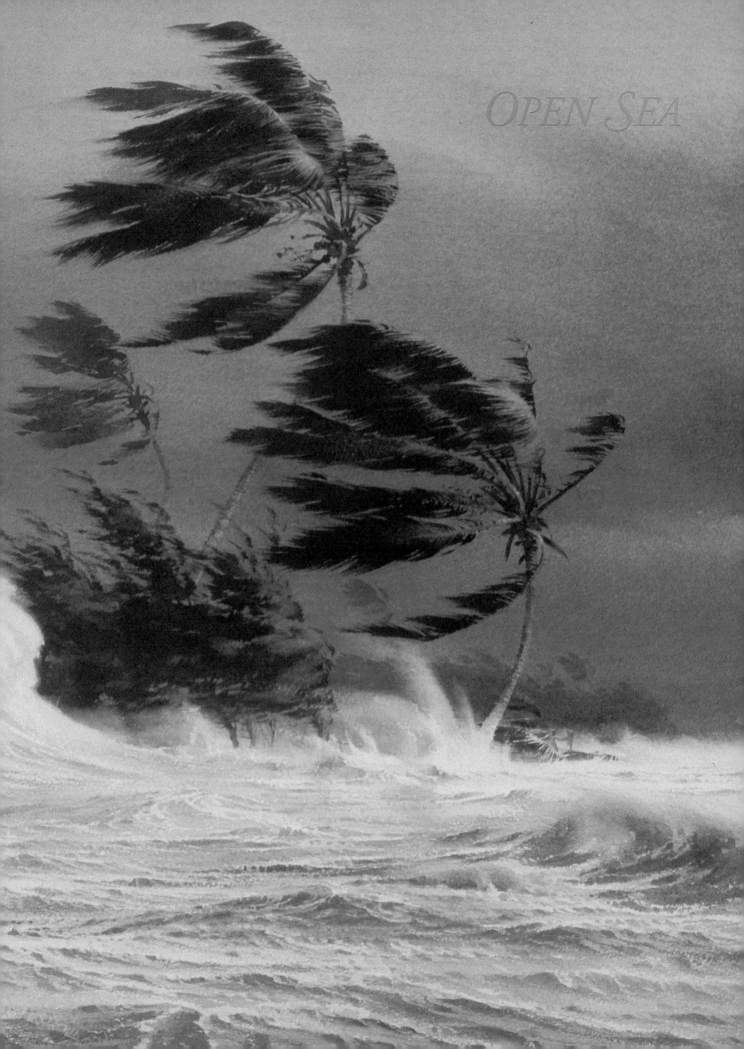

Carl G. Evers
CONVEYING DRAMATIC ACTION

When it comes to capturing water in flawless detail—its depth, swirling motion, and translucency—Carl Evers has no peers. Here he depicts a tidal wave smashing past palm trees on Florida's east coast. Before touching paint, Evers worked out the composition in a detailed pencil sketch, based on his observation of Florida waters in motion. The sketch was then transferred to a high-quality premounted watercolor board—he prefers Winsor-Newton, J. Whatman, or d'Arches—with a rough surface. Evers tests the colors he plans to use on scraps of the same watercolor board, where he can observe their relationships, experiment with mixtures for special areas, such as shadows, and see how they look after they dry. "Blues and greens are always a problem," he says. "Blues come out stronger than other colors, and often greens seem *too* green. They look artificial." To solve the problem, the artist often mutes them with a wash of yellow ochre or a bit of sepia.

Evers began this painting with washes of blue and yellow ochre for the sky and translucent deep green for the wave, overlaid with blue in the shadows. The shallow water in the foreground, reflecting the sandy bottom, is tinged with yellow ochre to convey reflected sunlight. Areas of spindrift and foam were left blank originally, then filled in with opaque white, which was blended into the deeper color already laid down. The dark green fronds and sepia trunks provide a counterpoint to the otherwise blue-green–dominated scene.

Unlike the imaginary *Tidal Wave*, *Hurricane*, the painting that opens this chapter (page 48), documents a real event. As waves crashed against a breakwall in Miami Beach in 1958, Evers watched the action of wind and rain from a shelter near the water's edge. "It was tricky walking," he recalls. "When I had enough, I went back to my room and made some little notations about the storm conditions and character of the waves." These became the basis for the complicated scene. Like Evers's other paintings, *Hurricane* combines thin, transparent washes overpainted with some opaque. In this case, the work was underpainted with a tone of yellow ochre to warm the gray-white of the watercolor board. A wash of cobalt blue was added to obtain the menacing gray sky. Then came the water, which the artist had carefully designed in a pencil sketch, transferring key details to the surface of the board. He washed in light green tones, leaving blank the white areas of the intricately patterned surface. He could still see his pencil notes of the trees through the transparent paint and filled in the foliage with dark green and sepia, stroking his brush up and to the left. Then he laid in the body of the exploding wave with opaque white, using an upward, sweeping motion. "I'm left-handed, which made it easier," Evers says. "Maybe if I were right-handed, I would have made the composition the other way around." For the flying spume, he fizzled out the white with a drying brush against the already dry sky. "I have to be lucky and leave it that way," comments Evers. "I don't want to touch it again."

The flat foreground water is darker toward the front and lighter in the distance, because of water in the air. Most of the streaks toward the breakwater came out too dark at first, so the artist went in with a stiffer flat brush, scraped it off, and then wet the paper again, which lightened the color. "It's important to have a good sketch ready, with the tonal values correct," Evers says. "That makes it a lot easier later on." And how did he devise the complex patterns? "Ah, one has to observe."

TIDAL WAVE
26" x 18¾" (66 x 47.6 cm),
watercolor, 1976

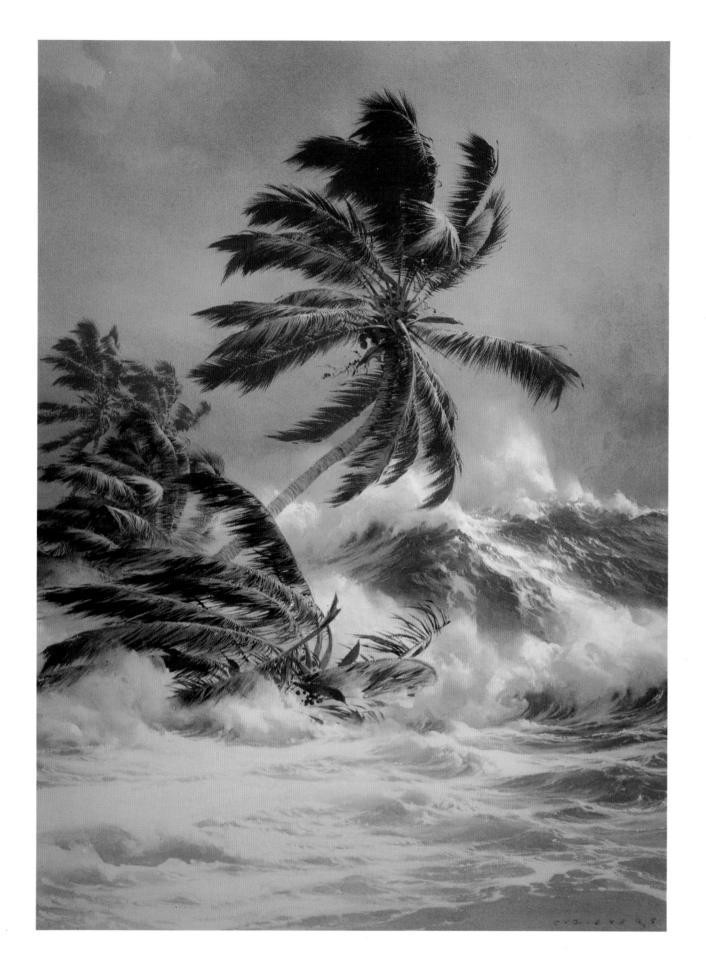

James E. Mitchell
DYNAMIC DESIGN

The title *Four Days* has nothing to do with weather or events—it took artist Jim Mitchell that long to finish the work. "Usually I agonize for weeks," he says. Perhaps the concentrated nature of the subject contributed to this, as the power of the sea holds attention here, without the need of ships, gulls, or other distractions. The painting is also a study of form, light, and color, employing some basic design elements.

Mitchell advocates getting away from the traditional rectangular marine format, with its predictable two-to-one ratio, to try something different—like this design within a square. "To add excitement, throw in another element, like a zigzag, and your painting will have added interest and movement," he suggests. *Four Days* is actually designed from a circle within a square, within which is a zigzag shape, like a backward Z. Starting at the middle left margin, the eye is led down at an angle toward the bottom center, where the dark foreground shape sends it up to the right, and then across the sky to the starting point again, completing a circle. Or, the eye can travel from the lower left foreground to the right and then left again, on a diagonal through the middle of the painting, then right, across the top of the waves. "The zigzag creates a jarring effect within the circular motion, and that creates a further agitated movement," the artist explains.

Four Days contains the germ of an experiment that would prove important later on. Immediately behind the dark foreground swell, on the brightly lit face of the sea, are a variety of dark-patterned curved lines—an electric calligraphy that is almost insignificant here but would later be employed to create whole paintings, entirely abstract. Mitchell believes experimentation and risk taking are integral to becoming a good artist. "The work of formula painters becomes boring after awhile because they paint the same thing all the time," he remarks. "It never changes, there's never any progress. If you don't investigate further, beyond what you're doing, you're a failure as an artist."

The sea depicted here is the North Atlantic, familiar to Mitchell from years of sailing plus a five-year hitch in the Merchant Marine. The Pacific Ocean is more azure and deeper, he notes, and has a much different fetch—the distance between a wave's crest and trough—resulting in longer swells. After sketching the basic structure onto the canvas, the artist blocked it in with transparent blue and green washes thinned with turpentine, to convey the transparency of the sea. Then he built it up all over at once, more interested in maintaining force and motion than in the specific colors used, which include liberal mixes of viridian and other greens, a variety of blues, and touches of alizarin crimson. "If anything, it's perhaps too sweet and green looking," he observes.

Mitchell feels the best creative painting is always spontaneous and quick. "You throw the paint on and it's done, and you should never touch it again. If the work is successful, fine. If not, tear it up and throw it away. An artist unable to do that is a poor disciplinarian. If he shows his failures, he's doing damage to himself."

This rough thumbnail sketch was one of several concepts considered.

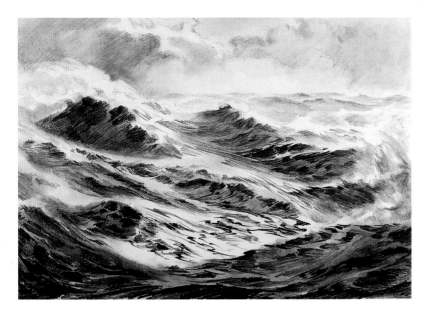

The final sketch for Four Days *was enlarged to scale from a thumbnail. As with all Mitchell's finished pencils, he attempted to solve the tonal problems while finalizing the painting's composition and design forms. Painting directly from the pencil, he had envisioned the color scheme from the outset, while letting the tonal values determine the play of color in the finished work.*

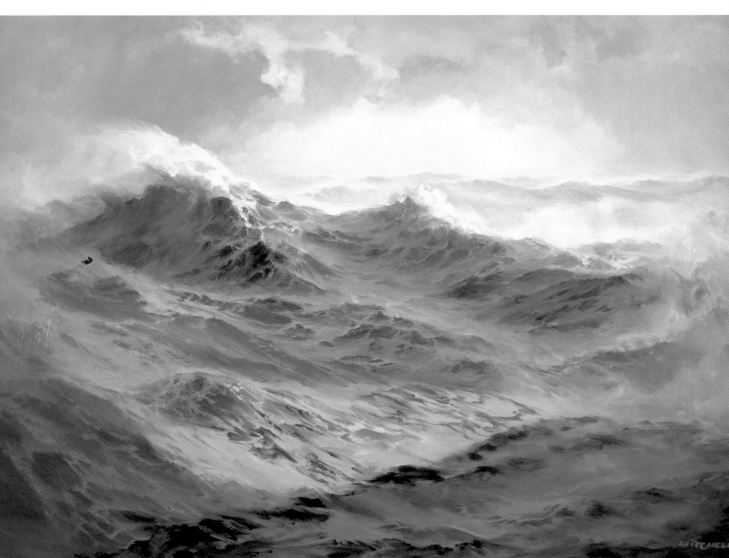

FOUR DAYS
34" x 50" (86.4 x 127 cm), oil, 1984

James E. Mitchell
WORKING WITH A LIMITED PALETTE

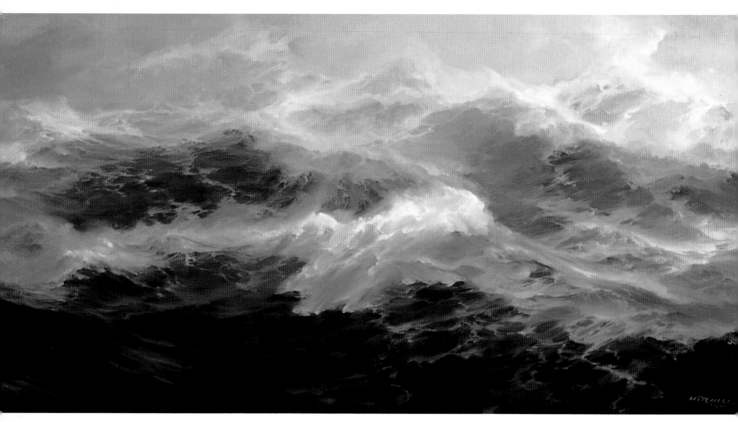

THE ROARING OF THE NOR'NOREASTER STUNS
24" x 48" (61 x 121.9 cm), oil, 1982

*The final design was altered a bit from this preliminary
pencil sketch, one of several worked up for the painting.*

Flying spume and breaking crests signal a winter maelstrom in the North Atlantic. "It's a particularly vicious, numbing type of storm," notes artist Jim Mitchell. "The wind alone can take your breath away." As the title, a line from England's poet laureate of 1930–1967, John Masefield, suggests, a Nor'noreaster can literally *stun* a man.

The impact lies in the menacing density of the water mass and the onrushing sheets of howling, wind-driven foam. Mitchell used a limited palette, mostly deep black-blues—composed of various mixes of Prussian blue and alizarin red, with a touch of white—but also a range of other blues and relief colors. After blocking in the design with pen and ink, the artist quickly covered the surface with thin blue and green washes. This was to alter the texture of the canvas, a material that Mitchell generally considers "a dreadful texture to paint on, because the white grounds create a false comparative value next to color." Once the wash coating of color dried, however, the canvas had a nice feel to it, and the paint flowed better, no longer soaking in. After several translucent layers of color, Mitchell began to build up the paint more thickly, ending with tints of titanium white scumbled on, applied with the side of a brush. The navy foreground helps to frame the piece in the viewer's eye—past its deep value, the other colors lighten, as distance diffuses and diminishes their intensity, creating perspective and depth.

Mitchell uses the whole range of blues, preferring "honest" colors like Prussian blue, ultramarine, and cerulean, and avoiding "phony" mixtures, such as aquamarine. To convey foam in shadow, he will mix Payne's gray, actually a deep blackish blue, with alizarin and white, or combine cerulean blue, ivory black, and alizarin crimson with white. "Pure black is very dangerous, and I use it only with extreme care and for limited reasons—never as a color," the artist cautions. "It creates a hole in the painting." His favorite green is viridian, along with the phthalo-cyanine greens, which, when mixed with other complementary colors, make great blacks. The intensity of almost every hue in his palette is cut with titanium white, which adds body and mutes the overrich tube colors. Mitchell prefers it to zinc white, which he finds takes too long to dry and will crack if applied too thickly before the underpainting has had a chance to dry. He avoids the use of driers mixed with his colors and warns that hairdryers "crack the hell out of a painting." He recommends natural drying as the best approach.

The artist may use a dozen or more brushes per day—mostly numbers 6 to 12 flats—any brand that will hold a chisel form. To keep them pliable, he washes them each night in a solution of Silacoil ("a magic timesaver"). For a palette, Mitchell prefers the white enamel top from an old kitchen table, which he finds gives a nice transparency to the colors being mixed without the distortion encountered with a big slab of plate glass. Although the palette is 30 by 42 inches (76.2 by 106.7 cm), the artist finds it's never large enough. "By the time all my colors are laid out around the rim, and some 20 brushes are lined up, I'm working within a six-by-six-inch [15.2-by-15.2-cm] square. I might just as well have one of those dumb little palettes you stick your thumb through," he says.

James E. Mitchell
EFFECTIVE PENCIL TECHNIQUE

In 1895, renowned sea captain–explorer Joshua Slocum was sailing off the coast of Patagonia during a worldwide voyage when, as he later wrote, "a tremendous wave, the culmination it seemed of many waves, rolled down upon me in a storm, roaring as it came. I had only a moment to get all sail down and myself up on the peak halliards [sic], out of danger, when I saw the mighty crest towering masthead high above me. The mountain of water submerged my vessel. She shook in every timber and reeled under the weight of the sea." By all accounts, he should have drowned.

Slocum had set sail out of Boston that year in *Spray*, a rebuilt 34-foot (10.4-meter) oyster boat. Three years and 46,000 miles (74,027 kilometers) later, he ended his historic voyage in Newport, eventually writing a book about his adventures, entitled *Sailing Alone around the World*, a feat that he was the first to accomplish. The book was reprinted in Sweden in 1980, and then in the United States four years later, with both editions illustrated by American marine artist James E. Mitchell, following Slocum's narrative. "In nautical terms a vessel is whelmed when a sea completely covers it and carries away everything loose on deck," Mitchell explains. "The *Spray* was whelmed by this rogue wave, an immense, earth-shattering force that comes out of nowhere. Slocum was under bare poles at the time. He climbed to the gaff, which is where he is [in the painting], and hung on for dear life. Had he stayed on deck, he probably would have been swept overboard."

In his 40 years as an artist, Mitchell, a painter in all media, has always made pencil his first choice. In his opinion, good draftsmanship is the most important fundamental an artist can learn. Mitchell uses pencil like a sculptor works a chisel, molding and shaping his subject matter. For the Slocum project, however, the chisel became chopsticks—just after signing the contract, Mitchell was in a car accident that broke two fingers on his right hand. Concerned about the deadline, he refused an arm cast, settling instead for taped fingers and a metal splint. He drew the *Spray* and the book's 139 other illustrations with only his two outer fingers and thumb.

Beginning with the sky, Mitchell rubbed cotton balls into graphite and applied them to the paper, for the lightest of the halftones. The rest of the

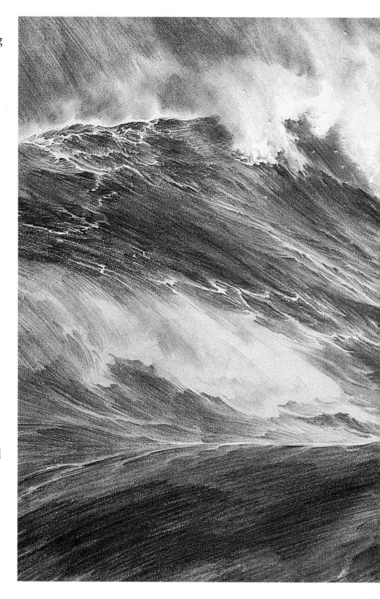

work was completed in what is called "the left-out process," working backward from dark to light tones, while leaving the highlighted areas pure white. The method conveys tonal transparency, enabling Mitchell to capture the quality of spume and aerated foam beneath the surface of the sea. As he worked, he tried to avoid erasing any lines. "You can erase," he says, "but it's never going to be as pure as it was when first rendered." This is a highly disciplined process requiring a constantly maintained balance of the overall tonal qualities of the drawing. It requires a few tricks, the artist notes, but a general pattern pervades throughout: The lightest areas are kept in the background, and the darkest tones are in the foreground.

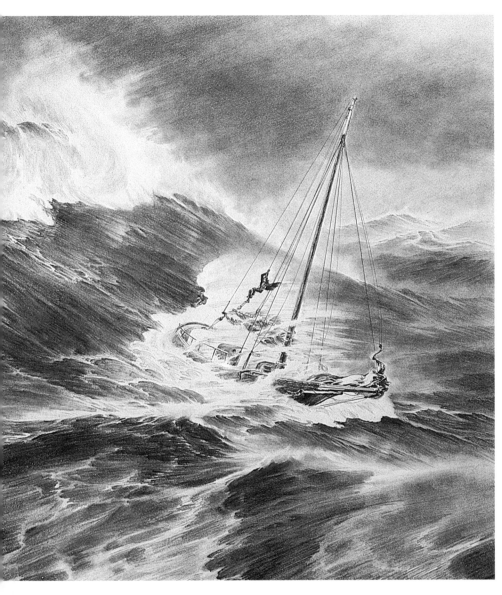

Mitchell's favorite tool is an Eberhard Faber pencil—jet black, extra smooth, which he uses on its side. He also employs a variety of Tortillon paper stumps, which range from three-quarters of an inch (1.9 cm) thick and 10 inches (25.4 cm) long to smaller, pencil-thick sizes, all with points at both ends. Mitchell uses them in ink, pencil, and charcoal, sanding them down to get the desired sharpness. He finds they spread a tone out evenly for a very soft effect. Stumps were used in the sky of *Spray* and the crest at the upper left, to further darken the original pencil strokes and cotton-ball tones. The torts were even used in some of the light nuances of shading in the boat itself. The rigging was done with a hard 3H

pencil; the heavier shrouds and forestay with a softer ebony one. For the greatest darker contrasts, the artist prefers Grumbacher's Layout Cartoonist pencil (number Z684), made in Germany, which is more intensely black and greasy. He also uses Grumbacher's graphite stick, called Bohemia Works, made in Czechoslovakia, which comes in grades from HB to 6B.

Mitchell's pencil work encompasses book and magazine illustrations, commercial advertising, shipline commissions, sketch work for portraiture, and figure drawings. "Thousands. I've saved them all," he remarks. "I hope some day to offer a wide-ranged retrospective collection of my sketch work."

Keith Shackleton
PAINTING FOAM

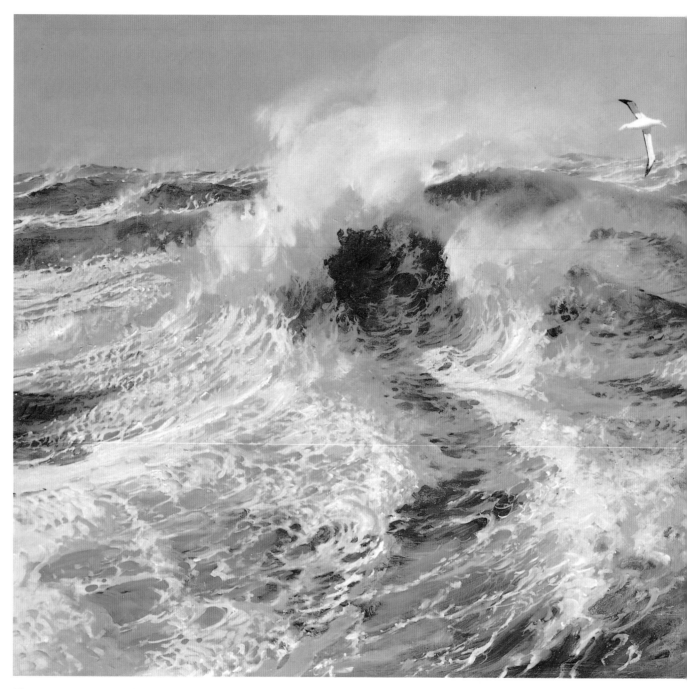

FORCE NINE IN THE SOUTHERN OCEAN
24" x 36" (61 x 91.4 cm), oil, 1979

At 50 degrees south latitude—"the furious 50s," as it is known among seamen—westerly winds sweep around the world with hardly any land to interfere. So constant are the gales that they have established an ocean drift, known as the westwind drift, which goes right around the globe. With no land to break its rhythm, the ocean develops widely spaced crests and troughs, unfettered and unrestricted. Here, a strong gale is building—44 knots, about 50 miles (80.5 kilometers) per hour—measuring nine on the Beaufort scale. "With the wind piping up to 60 knots, it's really a Force Nine, gusting to Ten, given the amount of white water in the picture," notes artist Keith Shackleton. The turbulence in the foreground is interference from the ship herself.

After roughly establishing the proportion of sea and sky, the artist began by laying in the principal wave shapes, designed after drawing many quick wave contours from life. "The shapes had all been worked out, organized, and put together with no more than the idea in the back of my mind that a single bird would be there ultimately—somewhere," he says. The water is a combination of indigo, cobalt blue, and Winsor green (a British pigment similar to viridian). Where the colors seem too cold, or too electric, Shackleton toned them down or muddied them up with a touch of alizarin crimson or even ivory black. Here and there, he added passages of pure ivory black for depth. Where waves have broken, a light opalescent green shows through, formed by submerged air bubbles. This effect is not seen in fresh water, the artist notes, "but you've got to achieve it if you want it to look like the sea."

The foam was added last, on top of the other pigment layers, similar to its natural position on top of the sea. The foam's spatial character defines the water's surface, just as a tattoo reveals the contour of an arm. But foam is more than a film—it is three-dimensional, with its own hills and hollows, one side lit, the other side in shade. The shadow color must be warmer than the color of the sea, or you get a confusion of tones, Shackleton notes. To convey white in shadow, he mixes equal parts of cobalt blue and cadmium orange for a lively pearly gray. The smokey spume effect was achieved by rubbing the surface lightly with his thumb.

The only element that fixes the scene in the southern ocean is the bird, an albatross. These superb gliders have evolved to live in a windy environment, soaring along a wave trough, then lifting into the next trough, as it is doing here. "As soon as you establish the bird in a curve of water like this, you're conveying its flight path," Shackleton explains. "You're presenting it with a hazard it's got to overcome." The artist knew the albatross had to be large enough to present visual impact. He anticipated the problems of scale—an albatross is over 11 feet (3.4 meters) across, yet dwarfed by the mountainous seas. What he didn't know was where to place it. So he cut out a little cardboard bird and moved it about until the position felt right. "The bird has got to relate to the picture—it can't just be stuck in anywhere," Shackleton says. Here, its placement is essential to the scene.

Keith Shackleton

CAPTURING THE RHYTHMS OF THE OPEN SEA

Seascapes are no more difficult than any other subject, at least for Keith Shackleton. They call for the same careful observation, coupled with an awareness of the forces that set water in motion. "The most modest of breezes begets catspaws and ripples to darken the surface," he notes in his book, *Wildlife and Wilderness: An Artist's World.* "Currents in the water body itself, flowing over an irregular sea-bed, will leave a surface expression. The two forces vie with one another as the breeze becomes wind and the wind becomes a gale, between them manipulating the shape, the period and the whole character of the resulting waves. If the water is deep and the fetch is great, they could form an ordered procession. In shallow waters, or with a weather-going tide, it could be turmoil."

Once there are waves, there are three-dimensional contours, giving the painter something to grapple with. Next to be considered is light—each wave has a lit side and a shaded side, the contrast in tones giving it the feeling of mass. All that remains is the superficial detail, notes Shackleton. "Subsidiary wind ripples chase each other over the principal heaving mass of every swell. Lacy patterns of foam overlay areas of opalescent cloudiness where air has been ground deep underwater by the weight of a breaking sea."

As the wind blows stronger the nature of the pattern changes," he observes, "parallel ribbons of spindrift lay stripes on the sea. Crests will be whipped off in flyaway banners that in sunshine form a momentary rainbow—and many people will be very grateful to the inventors of Dramamine."

The miles-deep ocean depicted here is off soundings—not on any chart. The horizon is high, the sky subsidiary to the enormous mass of the sea. A nice sailing breeze is blowing, and a sooty shearwater appears in the distance against the only break in the dark horizon, a counterpoint to the broad foreground area of foam. Darker passages are indigo blue. The foam, added last, was applied wet-into-wet, drawing up some of the blue paint below. When painting seascapes, Shackleton prefers slow-drying mediums for just this purpose. "The texture of oil paint, as well as its willingness to oblige, is an enormous help to a sea painter," he says. "Brush, palette, knife, and fingers all play their part. The patina of oil paint itself has much in common with the 'feel' of the ocean."

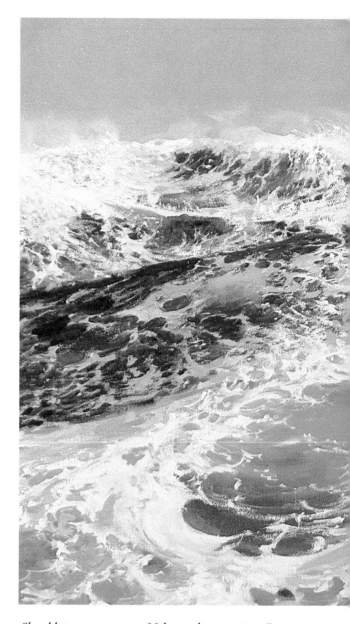

Shackleton once spent 23 hours hove to in a Force-Ten gale, off soundings, with waves as high as 50 feet (15.2 meters). But because the water was so deep, crests and troughs were widely spaced, resulting in a gentle gradient. "I was surprised you could have so much wind, while the contours of the sea stayed reasonably benign," he recalls. The circles of foam, quite common in midocean, are the rotational effect of waves breaking.

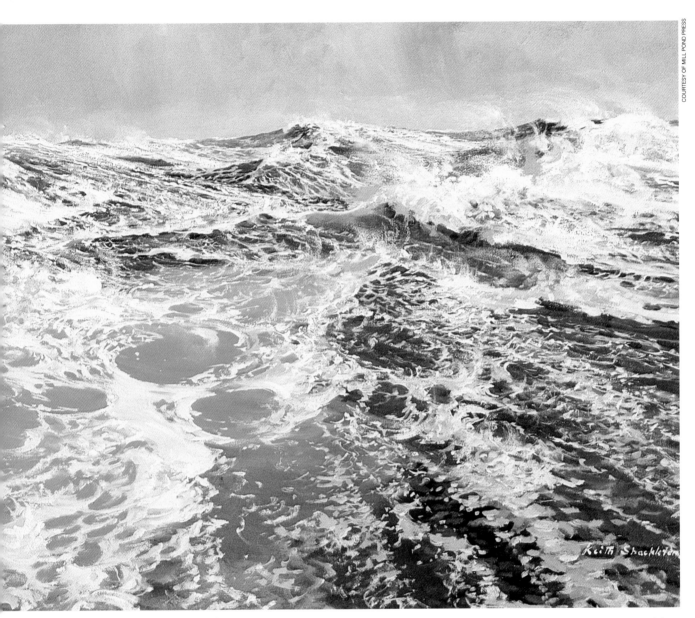

STORM FORCE TEN
24" x 48" (61 x 122 cm), oil, 1987

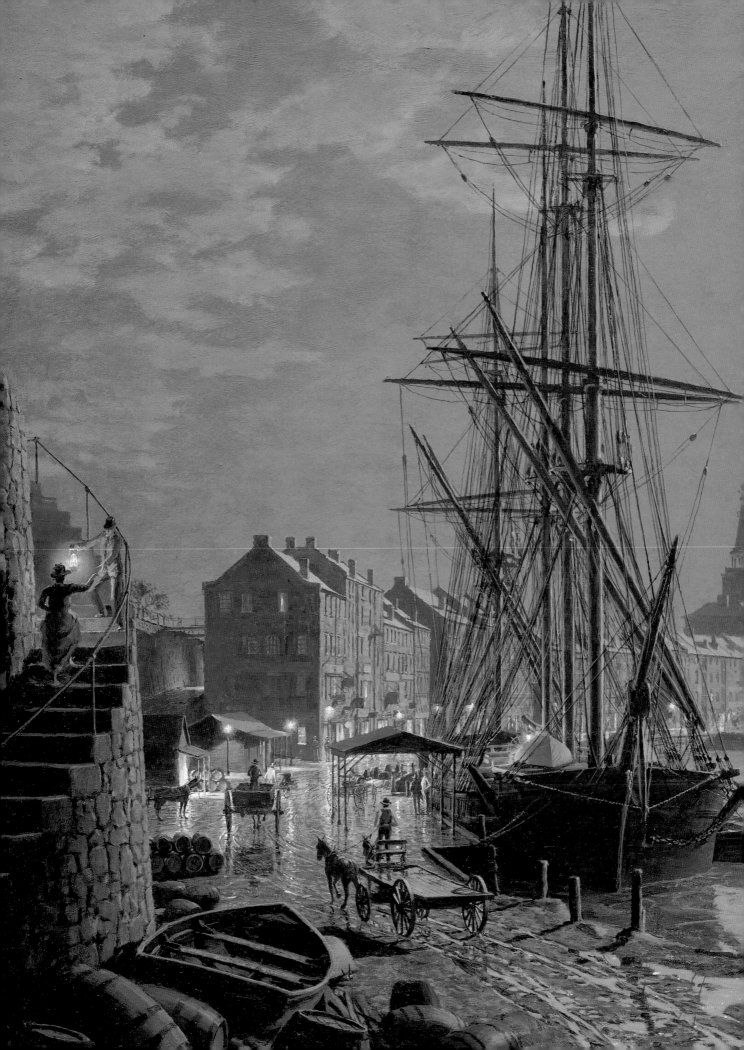

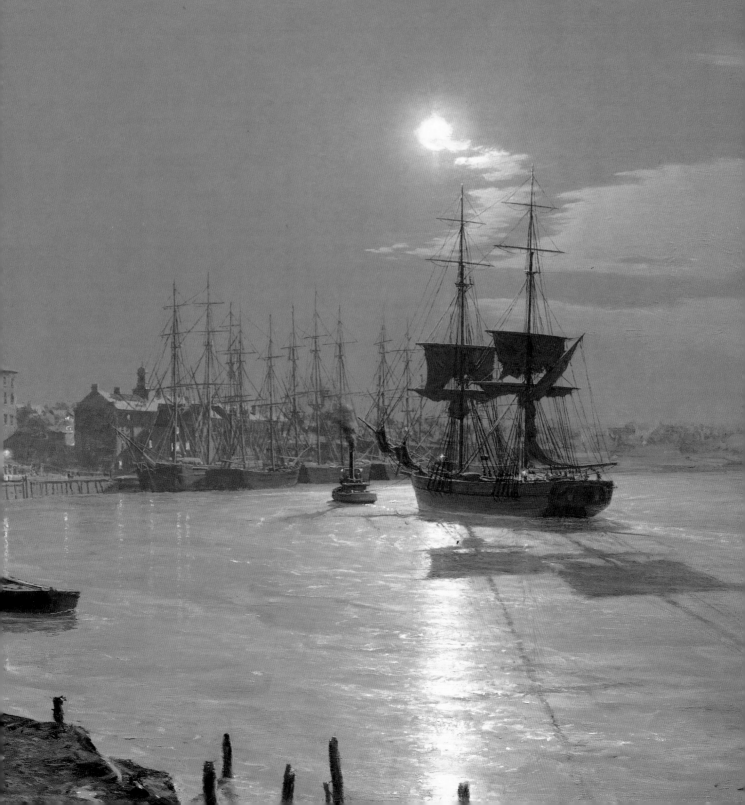

John Stobart
CREATING THE ILLUSION OF MOONLIGHT

MOONLIGHT ENCOUNTER ON THE MISSISSIPPI
28" x 44" (71.1 x 111.8 cm), oil, 1983

Log rafts were common on the Mississippi River during the 1860s and 1870s. Bound for sawmills in Natchez, Baton Rouge, and New Orleans, they floated with the current, guided by oar and sweep. The rafts rarely traveled on dark or foggy nights, but, according to ex–river pilot Captain Frederick Way, when the moon shone bright, the raftsmen usually "let 'er float," hanging a lantern on a pole to warn passing ships of their presence. In this colorful scene, the crew has borrowed the light to play cards in the shanty, unaware of the steamship bearing down on them until it may be too late. Such encounters were common, notes artist John Sobart, usually ending with the riverboat captain shaking his fist from the wheelhouse, exchanging angry shouts with the raftsmen below.

The mood and composition of *Moonlight Encounter* rank it as one of the most important paintings John Stobart has ever done. He was inspired by the etchings of nineteenth-century American artist A. R. Waud, who left behind vivid eye-witness accounts of river life long before the camera was invented. The logs angling out along the sides of the raft were probably used to fend off the river bank. A small boat was taken along so the crew could feed themselves by begging, borrowing, or stealing from farms along the way. Painting a moonlight scene is like painting a very dark daylight scene, with all light details taken away, down to an almost monochromatic tone. "They're contrived," Stobart admits. "You really wouldn't be able to see all these things. I give the paintings more light [than would actually be present], conveying the illusion of moonlight while emphasizing the reflections and silhouettes." Here, the sky consists of a mix of Winsor red, permanent green, and French ultramarine blue, with a touch of cadmium yellow.

In nearly all of Stobart's night scenes, one side of the painting is dark against light, the other light against dark, providing variety. In the chapter opener (pages 62–63), *Savannah. Moonlight over the Savannah River in 1850*, the artist combined French ultramarine blue and permanent green for the night sky, adding a cool yellowish haze around the moon. "The sun is warm but the moon is cool, which is why you need a lot of greens," he explains. The warm glow of the artificial lights provides the contrast that holds the viewer's interest. For the rest of the scene, the artist mixed blue and green with whichever warm color brought the shade to the right depth. There is no reflected light in a moonscape, but Stobart takes advantage of what the moon does provide—shadows. In this case, the masts and dramatic shadow of the brig to the right anchors the painting. For a moonlight scene to work, there must be a sense of recession, although, again, this is not really visible at night. *Savannah* is darker in the foreground and lighter in the background. "It's kind of cheating," Stobart says, "but you have to do it to create depth."

John Stobart
OVERLAPPING SILHOUETTES

Ironically, it was an English artist, John Stobart, who first adequately documented America's maritime heritage. "I found it to be a terrific challenge being the first one to recapture the history of some American ports," the artist recalls. "Nobody was painting this period when I started. No one painted San Francisco during the Gold Rush. Can you believe it? If it had been Europe, there would have been hundreds of paintings done."

Stobart places his clipper ships in majestic settings—in this case, New York Harbor at South Street, with the Brooklyn Bridge as a backdrop. The *Henry B. Hyde*, considered the finest and fastest ship built since the clipper era (1855–60), tows out under full sail on her second voyage to San Francisco in the fall of 1886. The *Hyde's* sails are well up on this windless day. A few strong gusts and she'd be in trouble, but it won't be long before she's in sailing territory in the lower bay.

For Stobart, one of the most important elements is the horizon, which he usually sets about a third of the way up from the bottom of the picture. From there, he establishes the sky early on. "People think the ships are the most important thing in a painting, but actually the sky is, as in any landscape," he says. "The sky holds the whole thing together." As he works the sky, Stobart paints around the sails, leaving blank canvas to be filled in later. Then working all over the canvas at once, he quickly blocks in the dark masses, such as bridges, piers, and barrels. "Never leave something in the foreground for the last minute," he advises. "Once you put it in, it changes everything. You absolutely have to work along with every value, and keep it all going at once."

Like the rest of Stobart's work, *Hyde* is actually a series of overlapping silhouettes, as if screens had been dropped into place, one in front of the other: bridge, boats, *Hyde*, piers. The milky atmosphere, which comes from the artist's London experience, further conveys a sense of depth. To lead the eye, Stobart often will include people looking at the main subject from the other side of the painting. "You'll look at the same thing they're looking at," he explains. "It's instinctive."

For reference material, Stobart uses antique maps, daguerreotype pictures, historic ship plans, and old street directories. Accuracy is paramount: "I have to be so careful with what I paint," the artist once told *Boston Magazine*. "There is always someone waiting to tap me on the shoulder and say, 'Uh-uh, that building burned down a week before that ship arrived.' Sometimes I would just like to move a house or something because it would make a better picture, but I can't." The vision, however, is always his own.

Stobart stretches his own canvas, tapping in the copper tacks loosely at first, so that the composition can be adjusted if necessary. In this case, he ended up moving the canvas to the right, to allow more space between the mast on the far left and the edge of the painting. This portrait of the famed clipper took about a month to complete.

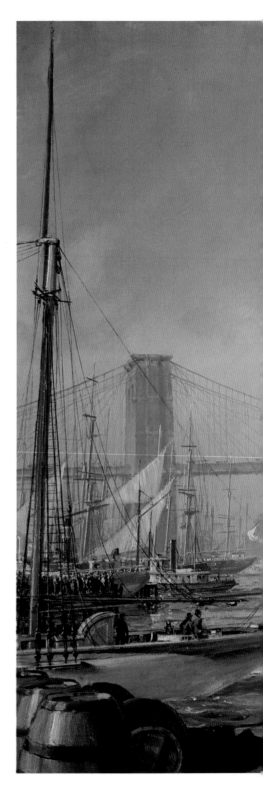

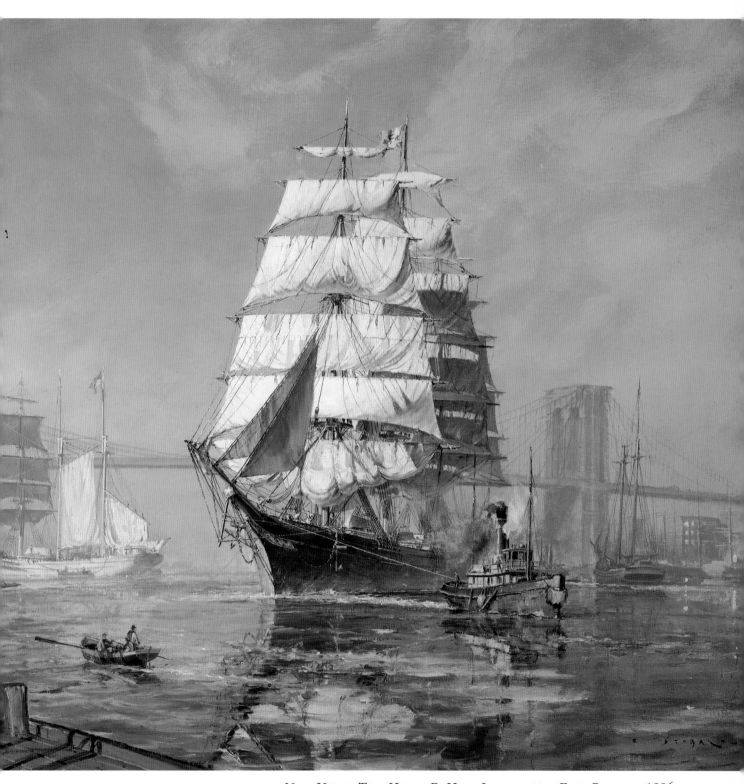

NEW YORK. THE *HENRY B. HYDE* LEAVING THE EAST RIVER IN 1886
28" x 42" (71.1 x 106.7 cm), oil, 1968

Thomas M. Hoyne III
CROSSED DIAGONALS

Whaling, which flourished in the mid-nineteenth century, was a dangerous business all around. Once one of the huge creatures had been harpooned, the crew of a whaleboat never knew whether it would be towed on a "Nantucket sleigh ride," or face the prospect of the whale diving deep. "Danger was ever present, as the large mammal could always attack a whaleboat or surface beneath it, destroying the boat and men alike," said artist Tom Hoyne. Its tremendous flukes could also be devastating.

That very danger is the subject of *Flying Flukes*, in which two whaleboats hang suspended, moving neither forward nor back, waiting to see what the harpooned whale will do next. The viewer's attention is riveted on the whale's tail, held there by the composition's crossed diagonals, which lead the eye to the center of the action.

To paint such scenes as accurately as possible, the artist had two models carved—a bowhead, shown here, and a sperm whale—each about four feet (1.2 meters) long, on a scale of 1 to 32. The artist himself posed as some of the whalemen,

standing in front of a mirror while his wife photographed him. Hoyne laid in the sky first, then painted the distant vessels over it. The whale consists primarily of indigo and burnt umber, with a bit of cerulean where its body reflects the sky. The deep arctic water was rendered with a mixture of indigo blue, Winsor green, and Prussian green. Combining burnt umber and indigo with white gave the artist the various shades of gray used in the whaleboats, figures, foam, and ships. The whaling vessel *Charles W. Morgan*, permanently berthed at Mystic Seaport in Connecticut, served as a major resource, along with plans and pictures of other whalers.

The golden age of whaling took place in the mid-1800s, when over 750 vessels ventured out from Nantucket, New Bedford, and San Francisco ports. Blubber oil, spermaceti oil, and ambergris made the sperm whale a prized catch for the whaling industry. Here, Tom Hoyne captures the moment when one of the 50-ton creatures, harpooned, headed for the depths as much as a mile below.

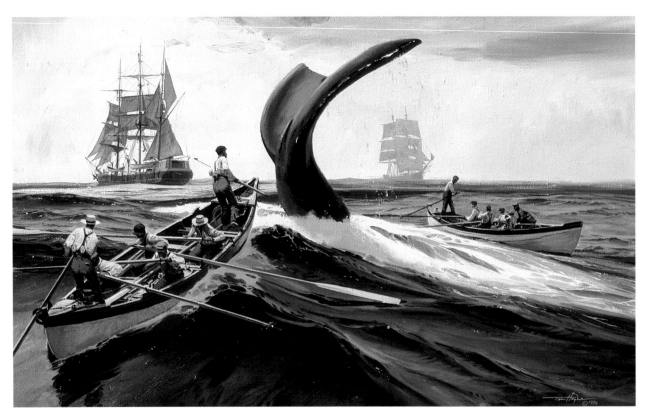

FLYING FLUKES
24" x 38" (61 x 96.5 cm), oil, 1986

Fighting Back is another classic composition of crossed diagonals, formed by the oars and furled sail of the foreground whaleboat and the surging whale. The focus is accentuated by the pool of yellow light that reflects on the water and glistens on the animal's flanks. The red-shirted figure in the whaleboat also directs the eye. As with *Flying* *Flukes*, the predominant color is indigo blue, mixed with varying amounts of burnt umber and white for browns, and gray. Here, the whale has thrown off the harpoon and the line has become tangled in its jaws. The men directly beneath the creature are in danger of swamping when it comes down, putting the eventual outcome in doubt.

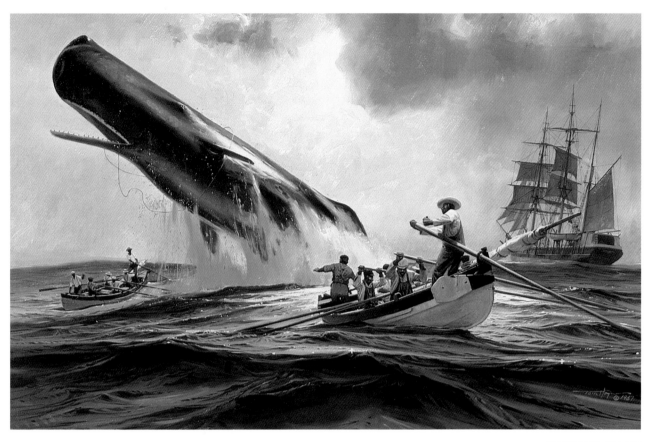

FIGHTING BACK
26" x 38" (66 x 96.5 cm), oil, 1987

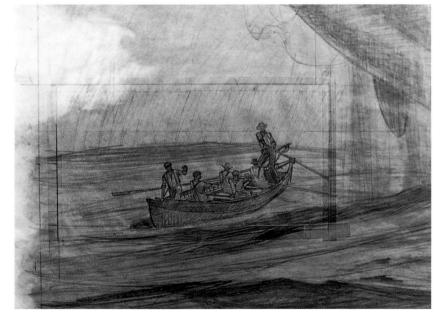

A close-up of Hoyne's sketch for Fighting Back *reveals how he worked on the more distant whaleboat as a separate thumbnail, taping it to the drawing later on.*

John Stobart
USING IMPERFECTIONS TO YOUR ADVANTAGE

SOUTH STREET BY GASLIGHT IN 1880
30" x 40" (76.2 x 101.6 cm), oil, 1972

John Stobart is perhaps best known for this evocative scene of bowspirits stretching over a cobblestone street in lower New York, which he painted at age 23. "*South Street by Gaslight in 1880* was my first attempt at tackling a moonlight subject and perhaps, judging by some critics' reactions to the painting, I had beginner's luck," the artist comments in his book, *Stobart. The Rediscovery of America's Maritime Heritage.* "Something about South Street, with all the vessels berthed bow-on to the street, immediately captures attention, and I knew the reflections in the wet cobblestone would work well. I had to keep the warm glow of the gaslights under control, balancing them against the cool hue of the pale moon.

"Painting a picture like this gets more exciting as it progresses," he says. "Each element contributes to the whole, building it shape by shape, until the real thing emerges before your eyes and you finally achieve the feeling of what it really must have been like." Achieving the mood required all the knowledge in the artist's repertoire, including understandings of reflective light, perspective, ship structure and proportion, and how canvas sails fold.

Consider the scene: The shops have closed for the night and only a few people are still about, including a horse-drawn cab, a fruit vendor, and some top-hatted gentlemen peering into store windows. The recent rain has left reflective surfaces everywhere, and the street shines with the reddish-golden glow of the gas lamps. The lamp on the right, shining on the sail, is a crucial part of the composition. So is the man pushing an empty cart in the foreground, moving into the picture at exactly the right spot. Other key elements include the curving railway and the fan of stonework between the railway ties at the far left, both of which lead the eye into the painting.

The glistening street was, in fact, the most difficult part of the painting for Stobart to do. A lot of work and careful perspective went into the cobblestones. To make them more interesting, some "very English" stone slabs were added in the foreground to break up the surface, which is further varied by holes and dips here and there. Where the railway bends, a number of cobbles are missing.

While accurate vanishing points are important to the composition, the scene is full of imperfections: Nothing is ruler-straight; the telephone lines sag slightly; the lettering *looks* hand-rendered; and not one of the yards that cross the ships' masts is lined up evenly with the next one. "It's all got to look right, and yet none of it is really perfect," the artist explains. "The picture has got to have a painterly quality, but if you get it looking like an illustration, you've lost it."

Signs above the shops feature the names of some of the artist's friends. Robert Gregory met the ship when the Stobarts first arrived from England. Peter Stanford was the director of the South Street Seaport Museum, which supplied the artist with reference material for the painting. Carpenter is a patron. And the artist's father is honored by a sailmaker's sign partially hidden by the telephone pole. Stobart further extends his personal world into his work by naming ships after his female friends.

Moonlight is incidental to the scene, and perhaps just as well, since Stobart painted the moon in the northern sky, a mistake reluctantly pointed out by an admiring sea captain. "I never knew the moon was always in the south," the artist admits with a smile. "I thought it went everywhere."

The scene on South Street was not to last. By the turn of the century, just 20 years later, steamers and barges would be taking over more and more trade, and by 1907 hardly any of the great sailing vessels could be seen at the pier in wintertime.

Carl G. Evers
PAINTING BATTLE SCENES

"Before I start drawing, I familiarize myself with the history," comments marine artist Carl Evers, famous for his paintings of naval ships and the sea. The *Olympia* was Admiral Thomas E. Dewey's flagship in the 1898 Battle of Manila Bay during the Spanish–American War. It was also one of this country's first steel-plated warships, replacing the wooden-hulled vessels that preceded it.

As the *Olympia* steams into action in this scene, cannonballs strike the water ahead of her bow. At right, the enemy's ships are burning. Smoke, coming from the fires and the ship's big guns and funnels, colors the sky. Working from a detailed pencil sketch, Evers started with an overall pale yellow tone, selectively overwashed with burnt umber and sienna. He tested the colors first on a separate piece of watercolor board and, when the mixture proved too reddish-brown, cut it with blue. "Always try out colors in advance," he advises. "Watercolor is difficult to correct." A mixture of these same tones can be found in the water and in the reflective sides of the gray battleship. Her bow, in shadow, has more blue in it, giving shape to the hull.

The rigging was done with a large brush wetted to a point. No rule is ever used in Evers's paintings—just a steady and experienced hand. Lines are established in the pencil sketch, when a mallstick often is used for long, curving strokes. These are then transferred to the watercolor board.

Evers is known for his accuracy, rendering ships with the thoroughness of a marine architect—an especially difficult task when working in watercolor. He walks the decks when he can, observing and sketching such details as vents, winches, and electronic gear. "I even include nuts and bolts," says the artist. In Olympia, the tiny figures of the men on deck and Admiral Dewey on the bridge are painted with equal precision and care.

Since the 1960s, Evers has painted 25 covers for the U.S. Naval Institute's publication, *Proceedings.* Twenty of these have been made into prints. In addition to the *Olympia*, Evers has documented the USS *Alabama*, the USS *New Jersey*, the USS *North Carolina*, the USS *Massachusetts*, and the doomed nuclear submarine the USS *Thresher*, among other, all commissioned by the U.S. Naval Institute. He also has painted private commissions, often from those wishing to commemorate an experience from World War II. "Since the individual's scene was etched in his memory, all details had to be accurate, even to, say, how the radar was placed on that particular ship in 1943," noted Evers's wife, Jean, in an article for the magazine *Sea History*. "Because gear on ships changed quickly during war years, Carl had to play detective on details." Evers relied on documentary photos of each war year, loaned by the U.S. Naval Institute library, similar pictures from the U.S. Navy offices in Manhattan, and his own sources. The effort involved in such painstaking verification should not be underestimated—the research on historic subjects usually takes more time than the actual painting itself, he notes.

OLYMPIA
29" x 22" (73.7 x 55.9 cm), watercolor, 1976

Evers started with this detailed pencil sketch, which he rendered after studying old photographs supplied by the U.S. Naval Institute in Annapolis and consulting his own extensive library.

Christopher Blossom
RE-CREATING HISTORY

Moonlit scenes are no more difficult to paint than any other, according to Christopher Blossom. In fact, because there will be reflected light to contend with, they may be *easier*, as long as you start with a strong design. Far more difficult is creating a believable environment, the artist contends. For this painting, he built a world out of his imagination, with the goal of "having the viewer think there is something beyond the edges of the canvas."

The subject is the Chesapeake and Ohio Canal, which connected bustling Georgetown with Alexandria, Virginia, by way of an aqueduct bridge, built in 1843. To prepare for the painting, the artist spent two weeks researching the history of the area at the Georgetown library, gathered blueprints and early photographs of the bridge and gatehouse, and visited the site, where the foundations of the old bridge still exist.

The aqueduct bridge was a quarter-mile (402 meters) long and constructed of wood on stone piers—an extraordinary engineering feat for its time. Here, workhorses pull coal barges toward the lighted gatehouse, where the lockkeeper operated the locks that lifted the barges to higher waterways. In the foreground, more barges await unloading, while past the bridge, out of sight along the left bank, chutes dumped the coal into waiting schooners below. In the middle of the river is a brig. The young town of Washington, D.C., glows in the distance.

Blossom played off the cool blue-green of the moonlit sky against the warm glow of the lights, which he used to focus attention on specific areas. He composed the sky from a mixture of ultramarine blue, viridian green, raw sienna, and a touch of white, with a bit of red added to knock down the green. The dark forms were executed primarily in Prussian green, Prussian blue, and alizarin crimson, with burnt sienna and ultramarine blue in the deepest shadows. The reflection on the water was glazed. Blossom painted rigging with a number 6 sable brush, a seemingly large size for such a delicate task, but "smaller brushes don't hold enough paint for a long stroke," he finds.

Today, Blossom would handle *Potomac by Moonlight* differently. "It's much too monochromatic," he maintains. "Instead of using such a limited palette, I would paint it with full-spectrum color, using a full range of values and hues."

Blossom used old architectural plans as a reference for the bridge.

POTOMAC BY MOONLIGHT
22" x 35" (55.9 x 88.9 cm), oil, 1984

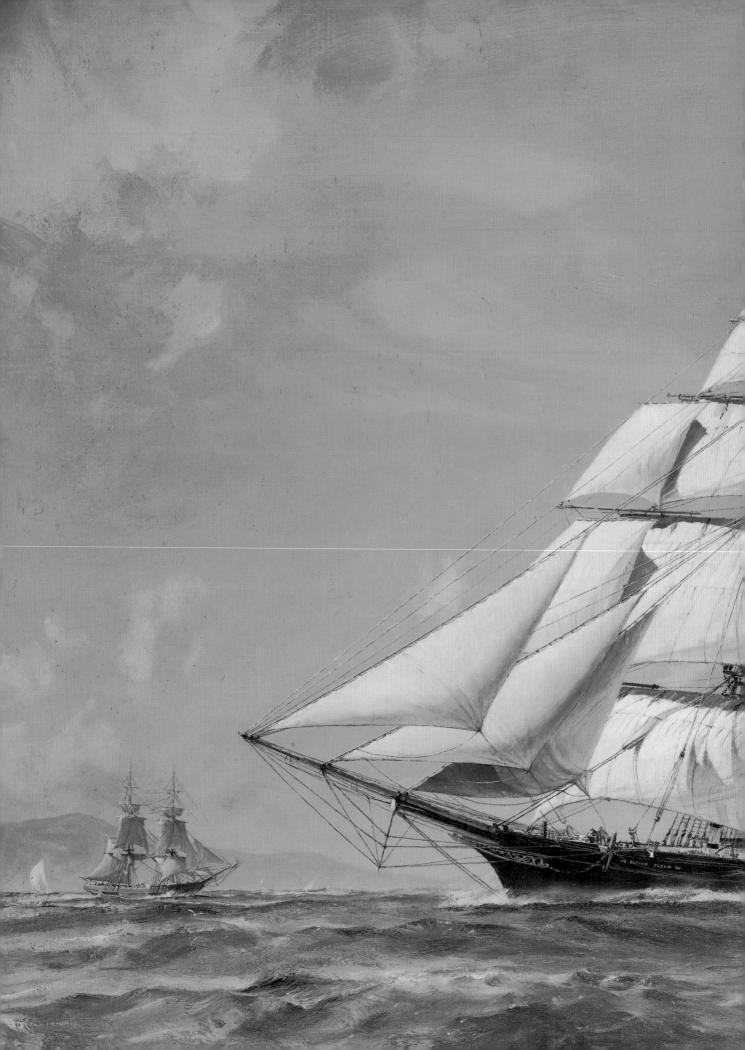

ESTABLISHING A THEME COLOR

HALIBUT CHASERS
30" × 36" (76.2 × 91.4 cm), oil, 1989

It's early morning and a fleet of fishing schooners chases after halibut in a choppy sea. The scene was inspired by artist Don Demers's memories of sailing in similar traditional boats. "I always will remember that thick, dusty light," he recalls. "It's coming through a lot of atmosphere, a lot of haze." Discerning viewers will guess the purposes of the foray from the dories nested upside down on the deck. (Haddock fishermen, who went out in the same type of vessel, stacked their lighter dories rightside up.) They will also recognize that the season is autumn—while one top mast is still up on the far boat, both have been pulled on the schooner *Elk*, in preparation for the harsh winter winds ahead.

Demers began *Halibut Chasers* with a limited palette expressing the theme color of the entire work: a warm, reddish mauve. He started with viridian, cadmium red deep, raw sienna, ultramarine blue, and cadmium yellow medium, expanding the range as he went along. The artist cautions not to get carried away with color changes. "Values are critical," he says. "You've got to be sure the sails are in front of the sky, not a part of it, yet not so dark that they end up something other than what you want them to be—in this case, a light amber tone under natural sunlight."

A single wave sweeps across two-thirds of the painting, building as it goes. The artist has placed the hull of the schooner where the wave is about to break, creating the illusion of steep angles in what is really a horizontal sea. Exaggerating the sea's rhythm is a common mistake, he notes, since short, steep chops are actually more the exception than the rule.

The water's fluidity was captured with a thin, dark wash of Mars violet and viridian green, with ultramarine blue added in the shadows and some white mixed with yellow for the highlights. To create the line of foam along the hull, he used a number 6 bristle brush, held sideways, twisting it as it moved along, and then went back in with a fine nylon brush for accents.

Preoccupation with texture can spoil a painting, as Demers well knows. On the other hand, sailing ships' fascination lies in the stark, simple beauty, contrasted with small areas of high detail. Here, Demers carefully refined the area of the anchor, channel plates, and the scuppers, adding a reflection of foam in the hull's black surface to help convey wetness.

The light source direction had to be figured carefully. It was simple enough to see that the strongest light would reflect off the sails, but it was less obvious to see that the low angle of the sun meant that the next strongest light would be reflecting off the schooner's wake and bouncing off the deck surface. Next came the sky itself, brightest near the horizon and gradually darkening toward the zenith. For a final touch, the artist added a pink highlight—composed of viridian, cadmium red light, cadmium yellow, and medium white—to the masts and cross trees, indicating the rising sun. "That's a strong, beautiful color," says Demers. "It makes the whole painting sing."

Thomas M. Hoyne III
MIXING AUTHENTIC SEA GREENS

The romance of the great schooners that once fished off the New England coast has appealed to many, and to none more so than Chicago artist Tom Hoyne. Hoyne spent his childhood summers in Maine and remembered watching the last of the fleet at the end of their sailing era. "Some of the ships were still working Ogunquit, and I was fascinated by them beyond all reason," he recalled. "It was during those summers in Maine that I not only learned to sail, but I also began to see the beauty and the hard life that were connected with the fishing fleet, particularly the men and vessels of Gloucester."

Life aboard the schooners was anything but romantic, of course. The fishermen braved ice, fog, and raging storms while working the Grand Banks, sometimes ranging as far as 350 miles (563.3 kilometers) out into the Atlantic. While the ocean pitched, they set their dories, hauled the catch, and furled the jib—as the men on the *Effie M. Morrissey* are doing here. Many lost their footing on such a "widowmaker," as it was known, with virtually no way of saving them once they disappeared beneath the ship. Hoyne's genius lies in his ability to create the sense of *being there*, on the spot, under creaking canvas sails, with a load of fish, pounding toward home.

It has been said that no one paints the sea better than Hoyne did. His waves gather force and subside in a manner so real, one can almost hear them hiss as they pass across the scene. "Tom could paint any kind of water," says his longtime friend, commercial illustrator Charles Kessler. "He could handle rolling seas, shoal water, or slick, oily swells. And he could get those air bubbles into the water better than anyone I ever saw." Hoyne mixed most greens himself, from combinations of indigo, a very dark blue, and various yellows. To that, he would often add tube greens, such as Winsor green, sap green, deep Prussian green, and, occasionally, cool viridian. The water here is primarily Prussian green, with a bit of cerulean blue and white added to cool off the lighter passages. The reflection of the patched and scarred sails—made up primarily of Naples yellow, Mars yellow and a touch of yellow ochre— extends like a huge awning over the sea.

The *Effie M. Morrissey* was launched in 1894 and named for the captain's daughter. In her first life, her prime, the *Morrissey* was a salt banker, shacker, and seiner, and also went dory handlining for haddock, eventually becoming a Nova Scotia vessel with a Canadian crew. In her second life, from 1926 to 1945, the ship was used under British registry for arctic exploration. After 30 years fishing and 20 more exploring, she then began her third life: With a greatly altered rig, and renamed the *Ernestina*, she worked for the next 30 years off the west coast of Africa in the Cape Verde packet trade, under the Portuguese flag. In the 1970s, thanks to the generosity of her many admirers, she was reborn as the *Ernestina–Morrissey* to start a fourth life as a training vessel, berthed at New Bedford, Massachusetts. "A remarkable history," said Hoyne.

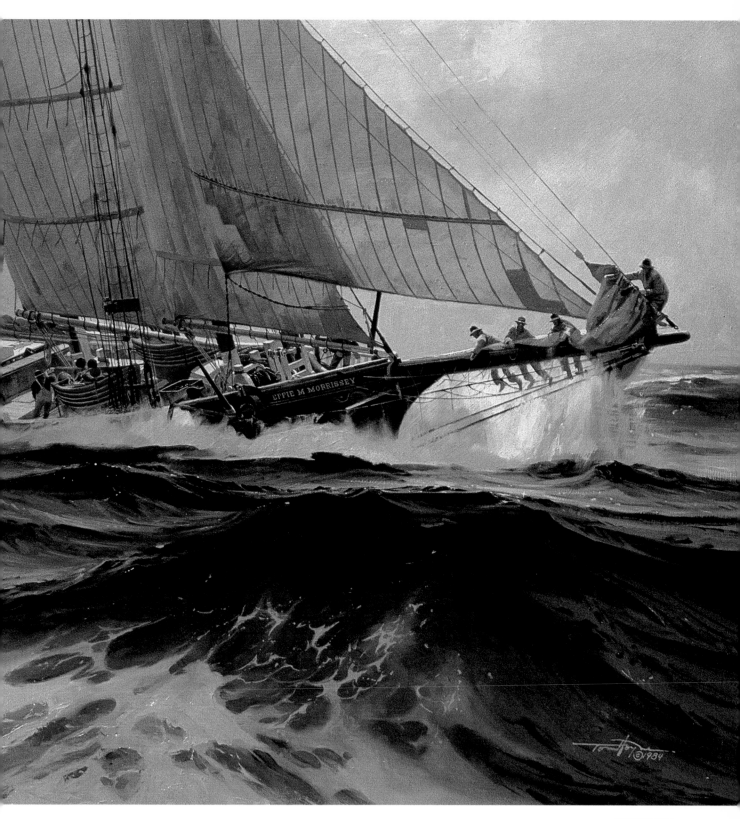

FIRST LIFE
27" x 36" (68.6 x 91.4 cm), oil, 1984

SELECTING A FOCAL POINT

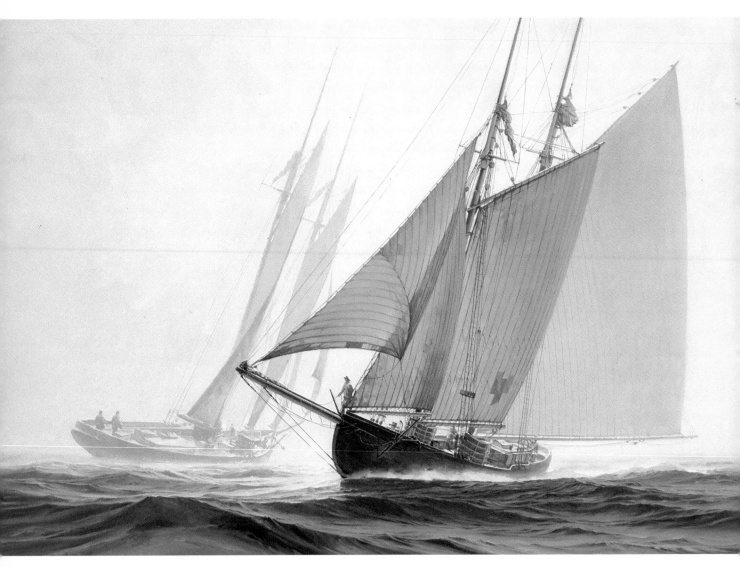

FOGGY REACH
24" x 36" (61 x 91.4 cm), oil, 1989

The scene may be historic, but the danger is timeless: two schooners passing in a veil of bright fog. One emerges abruptly, the other is in ghostly retreat, echoing an experience that the artist, Don Demers, once had while sailing from Newport, Rhode Island, to Camden, Maine. Demers was at the helm of an 80-foot (24.4-meter) yacht when a fast-moving trawler suddenly loomed out of the haze. For a moment it seemed the two might collide. "Instinctively, I moved the wheel one way, and the trawler's captain moved his wheel the other way, and we just managed to avoid each other," the artist recalls. "There's a tremendous amount of light in a luminous fog. It's very illusionary out there, almost ethereal. I've been in situations where I could hear a buoy ringing so loud it made my head hurt, but couldn't see it until we bumped into it."

Foggy Reach depicts two Indian-headers, so called because of the Indian names given to the first schooners of this type, and known for their beautifully proportioned design. Critical to the painting is its low horizon, which emphasizes the powerful presence of the foreground schooner and puts the viewer in the scene, as though watching from a nearby dory. The opposing lines of coming and going create the tension while the background is kept spare.

"It's not a quiet view," notes Demers. "There's a lot of foam kicking up at the waterline; both boats are heeling over pretty well." These were savvy seamen who knew the waters well and moved along at a good clip, regardless of the weather. "Both boats are on a beam reach, with the wind perpendicular to the hull, and they don't have their topsails set," the artist comments. "If they had to come about very quickly in the fog, they could."

After laying in the sky, Demers blocked in the hull with a warm gray, bordering on brown. This, contrasted with the much paler stern, defines the schooner's size—nearly 120 feet (36.6 meters) long. Resisting the temptation to go further with it, the artist turned to the other simple forms, the second schooner, sails, and water, ensuring that every mass and plane, horizontal and vertical, would relate properly. Texture and movement came later. Once the strong form of the sails were in place, Demers began blending them into the background with opaques, while the paint was still wet. The brilliant light sweeping across the painting's surface unifies all the elements.

As a painting progresses, Demers selects a focal point and stares at it awhile. Only then will he lay in crisp edges. The rest of the work appears softer, just as the human eye focuses on one object at a time, seeing everything else peripherally. "Stick with that focus," the artist cautions. "There are fewer sharp corners in life than you think. The minute your eye begins to wander and look at something else, that's another painting, that's not the one you're doing right now." Here, focus is concentrated at the bow of the near schooner, where the bow watch stands, while other edges are softer.

Demers's commitment as an artist is to document New England commercial sailing vessels dating from about 1850 to 1950. To prepare for this painting, he spent three days drawing and photographing a five-foot (1.5-meter) model at the Peabody Museum in Salem, Massachusetts. Finding the museum model was a lucky break— hundreds of these schooners were built, but few survive in photographs, and working from the scant remaining information places significant limitations on what a marine artist can re-create, which is why the few well-documented vessels are featured again and again. Once Demers discovered the model, creating the technical drawing took three days. The painting itself was finished in three weeks.

Donald Demers
CONVEYING TRANQUILITY

The peaceful atmosphere of this harbor scene at sunset was enhanced by the use of warm colors and horizontal lines. The idea was inspired by old photographs of boat traffic off Newport, Rhode Island, an area noted for yachting. "I wanted to show there was a lot of fishing and trade going on there as well," explains artist Don Demers. To establish a mood of tranquility, he kept the primary area of interest along the horizon: rocks, lighthouse, the schooners' decks, and the distant cloud bank peppered with sails. The schooners are moving away from each other, with no possibility of collision—a fact underscored by the two men aboard the vessel at left, shown looking back at the viewer. "They're in no danger. There are no rocks ahead. They don't care where they're going," the artist observes. Where objects do overlap, creating potential areas of tension, values and color contrasts are underplayed.

The viewer is brought into the scene by the large, abstract sail shape at left, then held by the greatest area of contrast—between the dark stern and the bright side of the schooner. The use of more intricate, secondary areas of interest keeps the eye moving back and forth between the two, stopped only by the strong verticals of the masts.

Castle Light's sense of serenity is further enhanced by its warm and harmonious color scheme. To saturate the scene with color, Demers began by underpainting it with a thin wash of burnt sienna, establishing a theme color. "From that point on, I was bound by that color," he says. "If things got too blue, I would know it in a second." In fact, the painting is so heavily drenched in warm hues that even a cool brown ends up looking blue, as happens in the left corner of the sky, composed solely of burnt umber and white. Here and there, the wash shows through, adding resonance and depth.

Demers started out with six colors: ultramarine blue, cadmium yellow medium, cadmium red light, alizarin crimson, burnt umber, and burnt sienna. He established the warm tones first, working in the shadows later on. As the painting developed, viridian green and dioxazine purple were introduced for cooler accents.

After laying in the sea, the artist allowed the thick layer of paint to dry for a day, until it began to get tacky to the touch, then pushed in the wave shapes with strength. The technique required two brushes: a small bristle containing the pigment (a mix of viridian and burnt sienna) and a soft, dry sable to feather the edges. Highlights were added later. "I would discourage a tendency to premix the paint too much on the palette before getting it down," Demers advises. "The Impressionists taught us the way you imitate light is by creating a vibration of light optically. Premixing flattens things out."

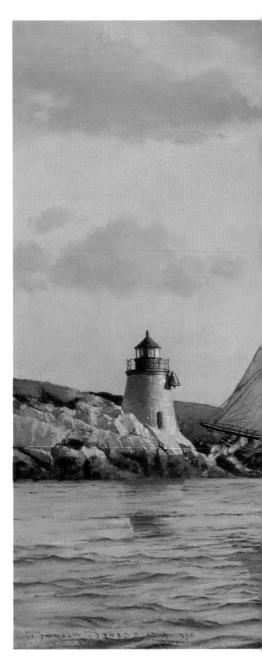

STANDING OFF CASTLE HILL LIGHT
15" × 25" (38.1 × 63.5 cm), oil, 1990

Thomas M. Hoyne III
USING A TISSUE OVERLAY

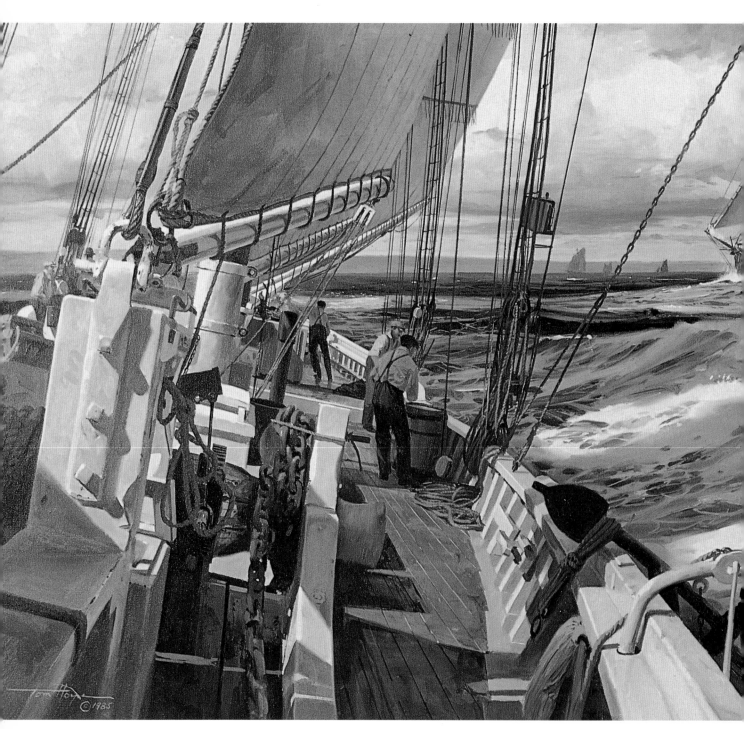

RUNNING BY
24" x 40" (61 x 101.6 cm), oil, 1985

To experience what it must have been like to sail the great fishing vessels of the last century, Tom Hoyne often booked passage on *Adventure*, one of the few remaining all-sail schooners out of Camden, Maine, and now under restoration in Gloucester, Massachusetts. These trips inspired *Running By*, which shows the newly built *Shepherd King* about to pass the clipper bow schooner *Norumbega*, with her seine boat trailing behind. By painting from the perspective of an on-deck observer, Hoyne brings the viewer into the picture and displays his knowledge of the equipment on board.

Hoyne began his paintings with compositional sketches, enlarging the final version to full size by means of a grid system. Then he penciled in the people and the rigging, and drew out the water patterns as accurately as he could. "I have always felt that a good painting hangs on a good halftone pattern," the artist once explained. "[It] should look good in black and white as well as in color."

After making a full-size pencil drawing on tissue, Hoyne blackened the back of it with a graphite stick and transferred it to gessoed Masonite or canvas. He left the tissue taped to the top edge of the painting surface, however, so he could flip it up and down to check the position of the figures, deck, and rigging details. Using the tissue as a guide, the artist painted quite broadly as he blocked in the scene, transferring lines onto the canvas as needed and adding progressively finer details as he went along. "Since I like to paint large areas at a time, I cover up a log of the initial drawing and then it's lost," Hoyne explained. "With a tissue like this, I can lay it right down and get the drawing back in the right position. This probably is the part of my procedure that is really unorthodox—I don't know anybody else who does this." Then Hoyne finished the painting, working pretty much top to bottom. Occasionally, he used a Faber-Castell Micro nonlead pencil for drawing rigging over oil.

Shepherd King was the second knockabout built, launched in 1905 by Oxner and Story in Essex. She fished for two years out of Boston before being run down off Cape Cod in a summer fog. Built in 1890, the *Norumbega,* a halibuter and seiner out of Gloucester, had a longer life—16 years—before colliding with a four-master off Fenwick Island, Delaware.

Christopher Blossom
WORKING FROM SHIP PLANS

Night fishing for mackerel began in the late 1880s, when seiners discovered they could locate schools by watching for phosphorescence stirred up as the fish broke the surface of the water to feed. Here, a man high atop the masthead scans the horizon, while others lounge about, ready for the call. *Waiting for Mackerel* started out as a fleet of fishing schooners but kept getting narrowed down until a single vessel remained, in a tight vertical format. "I realized I was interested in the way this one boat looked against the reflection of the water," artist Christopher Blossom explains.

The artist's training as an industrial designer helped him to conceptualize a ship's plan in three dimensions and change its angle to this oblique, gull's-eye view, following a ship plan for accuracy. "You have to be able to envision it in your mind from the three-plane views," he observes. "Obviously, you don't always find photographs of what you need, and when you do, it's usually from the wrong angle. If you have the plans, you know what the ship looks like, and you can paint it from any perspective."

Blossom paints on double-primed linen canvas, which has a fine, smooth weave. Usually, he does not make color studies or elaborate drawings. Instead, after dividing the canvas into quarters, he transfers the information he needs with a brush, freehand, from a thumbnail sketch. Here, he blocked in the scene within an hour or two, establishing color, value, and tone. By covering the whole surface at once, instead of one area at a time, he was able to introduce all the colors he intended to use in every part of the painting, an approach that also leaves room for spontaneity. "You can't really anticipate the way colors will mix," he notes. "Sometimes, the texture of the brush will give you an idea for the way the water is going to work."

The schooner's sails were laid down in thick washes of Prussian green and sienna, each pigment layer then scrubbed off with a dry brush to convey the worn look of old canvas. Both sea and sky consist primarily of Prussian blue and ultramarine blue, with green added to the water to evoke the reflecting moonlight. The dramatic foreground passages were painted basically dark to light, with more detail worked into the light areas. The artist used titanium white for the bright reflections, finding its opacity and stiffer volume helpful in creating texture. As to how he achieved the final effect, Blossom will only say, "I changed this shape a little, brought that up a bit more, toned this down. I'm still experimenting with it. It's basically trial and error."

WAITING FOR MACKEREL
22" x 36" (55.9 x 91.4 cm), oil, 1988

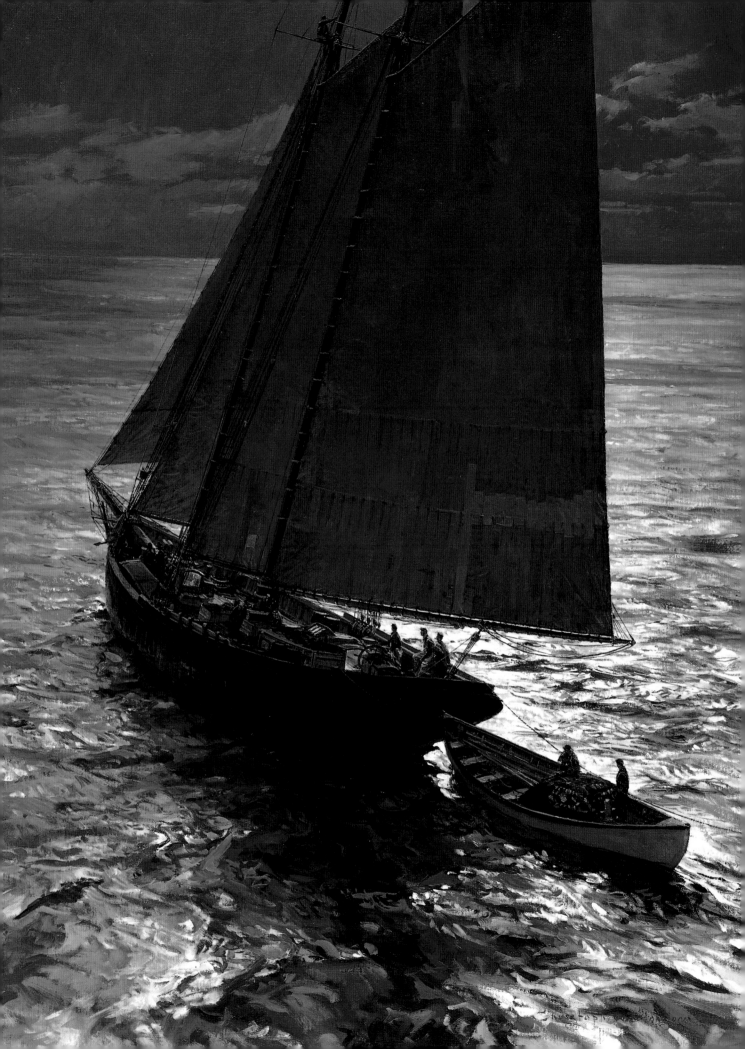

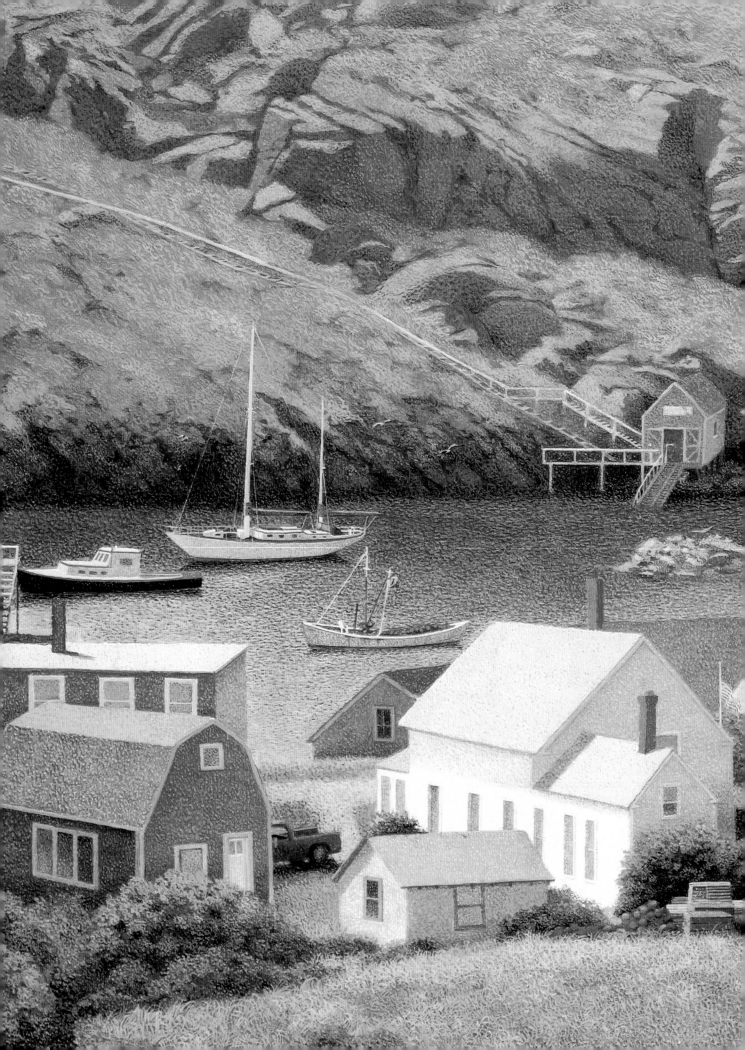

HARBORS

L. KRUPINSKI
A.S.M.A.

John Atwater
PAINTING WITH HIGH CHROMA

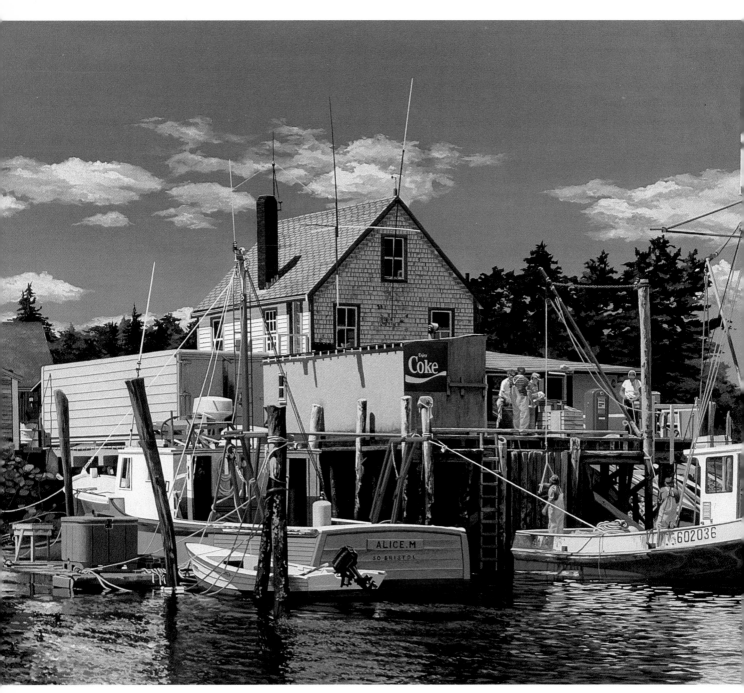

ALICE & I.O.
30" x 48" (76.2 x 121.9 cm), oil, 1985

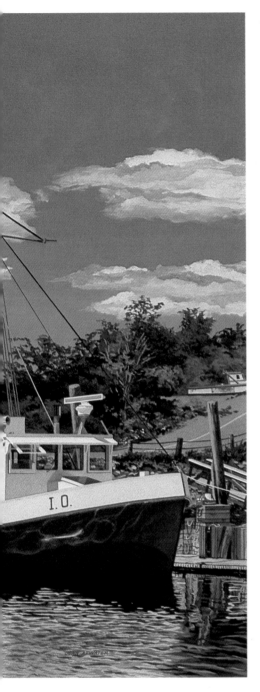

John Atwater has an eye for color. His paintings display a wide range of vivid hues. While he was sailing through a small harbor in Maine, his eye was drawn to the bright yellow slickers of some fishermen unloading bait on a pier, a Coke sign, and a bright red pump. The rest of the scene was rather dull, but the artist saw its potential. Back at his studio in Connecticut, working from photographs he took of the scene, he accentuated the already-bright hues and added saturated color where there was none.

The *Alice M.* received a coat of Winsor green light, the cab of the *I.O.* a double shot of orange and mauve. The gray Coke shed was enhanced with cerulean blue, and the shadow side of the main building took on a purplish cast. Reflections in the water were intensified with as much pure color as Atwater could get away with: green, purple, orange, yellow, and ultramarine blue. Even the whites were enhanced, with yellow and orange.

Atwater uses colors out of the tube only when the corresponding real-life hues are extremely brilliant—such as for oilskins in direct sun, or a fluorescent lobster buoy. Here the fishermen's slickers are pure cadmium yellow in the sunlight, grayed with raw sienna and a touch of blue in the folds. Cadmium orange defines the outfit of the fisherman standing on the pier. The pump is cadmium red medium in the sun, and alizarin red in the shade.

A typical pale cerulean sky was overhead that day—not interesting enough for Atwater. The artist searched through his files until he came across a reproduction of a painting by nineteenth-century French artist Camille Corot that better suited his needs. The resulting sky is ultramarine blue with some cerulean, becoming lighter and warmer toward the horizon and modulating to the light greenish hue just above the *I.O.* "For marine painters, the sky is often 50 percent of the image," Atwater says. "To have your painting really come off, study the sky and paint it in a moving and sensitive manner."

The artist's palette includes such high-key colors as Winsor violet, Winsor emerald, and scarlet lake. Raw sienna also is used often, even in the shadows of a white. Once the entire canvas is covered, Atwater begins a tuning process, in which many colors and values are adjusted—some passages are brightened, others softened. "Painting with vivid hues is a challenge," says Atwater, "because it can be a fine line between bold color and harsh color, or having too much color without an overall harmony within the palette." In the end, the lively hues and busy marine activity in this painting offer a double appeal.

TANNIS IN CARVER'S HARBOR
15" x 26" (38.1 x 66 cm), oil, 1990

West Fraser's paintings shimmer with color, a result of the artist's deliberate juxtaposition of seemingly dissonant color harmonies. In *Tannis in Carver's Harbor*, for example, the clouds are red-violet and blue-violet backlit by yellow-green, creating color intersections that keep the eye busy. After assessing the subject's potential color range and the mood he wished to convey, Fraser placed a hexagon within the color wheel and came up with the basic harmony for the painting: blue-violet, red-violet, red-orange, yellow-orange, yellow-green, and blue-green. "I always have difficulty with the purples and blues being dominant in marine scenes," Fraser admits. "In retrospect, this painting needed more gray-blue-violet—and less red-violet—in the sky."

Color harmonies can be created by imposing almost any shape within the color wheel: hexagon, trapezoid, rectangle, triangle, or square. The colors the shapes point to determine the pattern—primary, secondary, or tertiary hues of different intensities, tints, and shades. Discord, such as Fraser achieves, comes from using a hue just outside the harmonious configuration. "If you throw in a color not in harmony, it will make the whole painting shimmer."

Marblehead is also built on the harmonious arrangement of six colors: red, orange, yellow, green, purple, and blue. To offset the dominant blues, the artist added several intense spots of orange in the sky and water; similarly, yellow highlights balance the purples, and the green boat on the right balances the reds.

Marblehead is composed around an oblong oval tilted to the bottom right. The turn is made at the green bow and its reflection in the water, with focus in turn moving clockwise to the mooring buoy, skiff, lobster boat, church steeple, and sky. Once there, the viewer's eye gets lost, only to fall again to the green boat, whose bowsprit shoots the viewer back into the action. To increase the intensity, Fraser chose a yellow-orange sky, which set up a shimmering, discordant effect with the predominant blues.

MARBLEHEAD, MASS.
24" x 40" (61 x 101.6 cm), oil, 1987

John Atwater
COMPOSING FROM PHOTOGRAPHS

In *Early Morning*, a village harbor appears to float between sea and sky, but things are not as they seem. John Atwater painted this sunrise scene from reference photographs taken at midday, adjusting the colors and shadows accordingly. The clouds come from a picture of an early evening western sky, but since the Maine coastal town of South Bristol faces east, and therefore could only be illuminated by the rising sun, the artist transformed them into morning clouds and made the water reflections to match. In addition to changing the time of day, incorporating clouds that weren't there, and altering the water, he eliminated the real landscape on the right to open up a distant view. Finally, he added more boats to the harbor. Atwater's credo: Don't let the facts interfere with artistic inspiration.

The sky was airbrushed for a seamless effect, the color modulating from ultramarine blue to very pale yellow, with a touch of raw sienna near the horizon. A band of warm gray indicates offshore fog. The clouds are gray and orange, with shadows of ultramarine blue, Winsor violet, and some cerulean blue. The light on the landscape and buildings is quite a bit warmer, with the focus on the cadmium red roof. Whites are intensified by the addition of small amounts of cadmium yellow and orange.

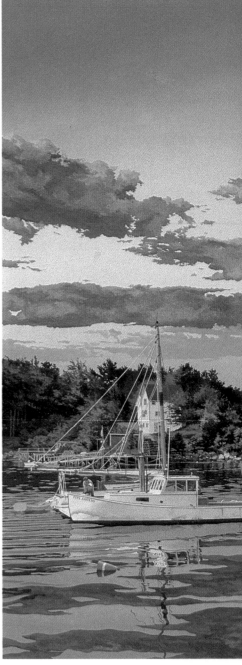

This pencil sketch shows the beginning stages of Early Morning.

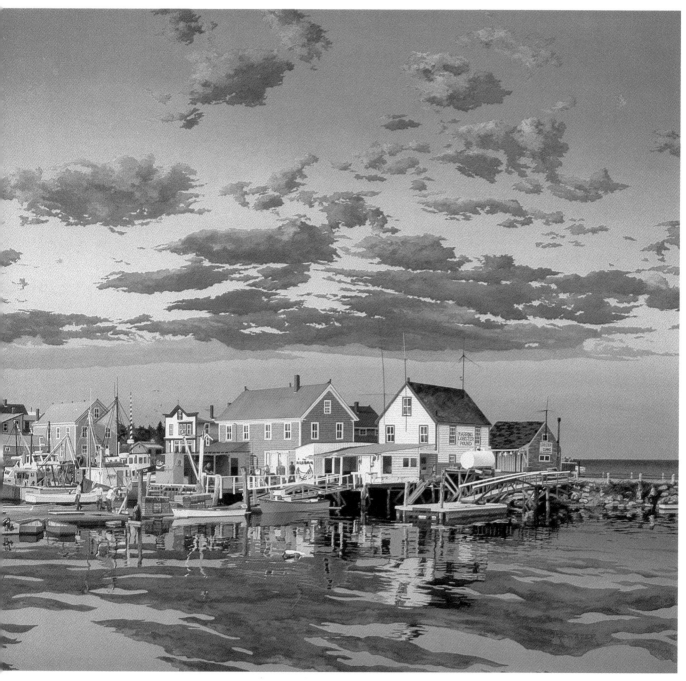

EARLY MORNING
40" x 60" (101.6 x 152.4 cm), oil, 1987

To compose a painting, Atwater often projects many transparencies from different scenes or cuts out pencil tracings and moves them around on the canvas, making sure that each is photographed or drawn from the same elevation, so that they will be viewed from the same perspective when added to the scene. He adjusts for common photographic distortions, such as foreshortening, by placing the boat or other object at the same visual distance from the viewer as it was originally photographed. Subjects in wide-angle shots, in which parallel vertical lines begin to curve, are redrawn straight.

PLEIN AIR WATERCOLOR SKETCHING

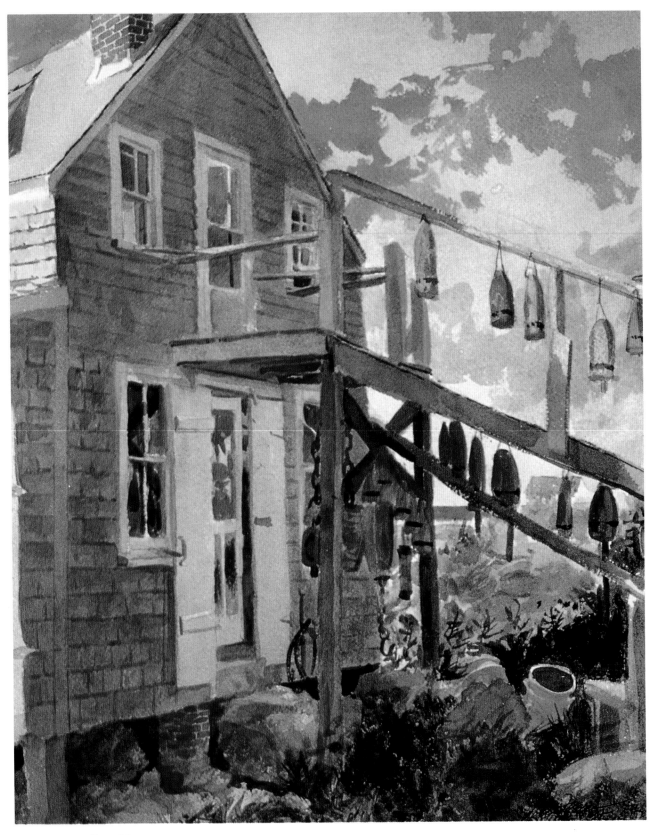

MONHEGAN FISH HOUSE
12" x 14 ½" (30.5 x 36.8 cm), watercolor, 1987

Color sketching outdoors is a joyous part of painting for West Fraser. In the studio, he concentrates on large oils and meticulous watercolors; outside, however, he feels freer, and his work loosens up and simplifies. "It's challenging to try to capture the essence and edit details while creating a sense of reality and atmosphere as quickly as possible," he comments. "Painting from life is when you learn how things really work, as you scramble to get something down while the light changes, the weather changes, and boats swing with the tide."

Fraser carries a French easel hooked to a backpack, scouting promising spots a day ahead when possible, returning when the light is right. The easel is fitted with homemade cardboard boxes, containing brushes, paint tubes, pencils, and liquids. Fraser prefers sable for watercolor brushes. His favored finer-haired rigging brushes include Isabey number 7 Kalinsky sable, Traceur Universal, Winsor-Newton series 859, and sign-painter liner brushes. The color sketches take him from one to five hours to complete, depending on their size, complexity, and whether he has time for two sittings.

The artist's interest in plein air painting began in 1987, on a trip to Monhegan Island, Maine, which is noted for its steep cliffs and summer art colony. "Monhegan was a beautiful place, and the air was charged with art," he recalls. "I got the confidence after that week to go anywhere and paint outdoors." Fraser found he was not the only one so inspired—once, when he had finished *Buoys* and was packing up to leave, he discovered resident artist Jamie Wyeth on the other side of a set of traps, painting the same subject.

Fraser's island experience has had other practical benefits: Working outdoors on populated Monhegan, while onlookers watched and talked to him, taught him to build concentration; on Vinalhaven, an island farther up the Maine coast, he learned how to handle fog. So far, Fraser hasn't based a studio painting on a watercolor sketch and isn't sure if he ever will. But, he says, "I've taken some of the editing from plein air painting and I'm using it in my studio more and more."

TUG, GREENPORT, N.Y.
*8" x 10" (20.3 x 25.4 cm),
watercolor, 1987*

MONHEGAN BUOYS
*10 ½" x 14 ¾" (26.7 x 37.5 cm),
watercolor, 1987*

CREATING A GOOD FOG GRAY

SOCKED IN
26" x 60" (66 x 152.4 cm), oil, 1986

A group of fishermen standing on a wharf in their yellow slickers provided the inspiration for *Socked In*, a harbor scene from South Bristol, Maine, a frequent summer home of artist John Atwater. The curving road leads the eye into the center of the scene and the bright spots of color provide points of interest. To keep the viewer's eye from drifting upward into the sky area, Atwater darkened the fog beyond its real-world level. More boats were added on the left, as were some rocks, a wall, and trees on the right, to flesh out the horizontal view.

Atwater spends hours in museums with oil pastels and museum board, accurately recording the colors and values of marine paintings he admires. Selecting five or more areas of a sky, for example, he reproduces two-inch (5.1-cm) color samples on a five-by-seven-inch (12.7-by-17.8-cm) card for later reference in his studio. The fog grays in *Socked In* are based on his study of the cloud colors of the nineteenth-century marine artist Alfred Thompson Bricher. Following Bricher's formula, Atwater combined ultramarine blue, cadmium red, and white, plus small amounts of cadmium yellow, raw sienna, Hooker's green, and Winsor violet, to develop a neutral gray just about midway between black and white. To add richness and texture, he then divided the mixture into four portions,

adding small amounts of warm or cool colors to each, to create a variety of warm and cool hues of basically the same gray value. As he painted, he added varying amounts of the gray to local colors, so that the entire scene became saturated with the quality of the fog.

The foreground elements, least effected by the intervening mist, exhibit the greatest amount of their natural color, but as the eye views more distant objects, the veil of moisture in the air increases, diminishing the amount of light reflected from each object. This haze modulates all hues and values toward its own until the most distant objects are hardly visible at all. Atwater achieved this by adding the same paint mixtures used in the sky to the objects in the landscape, increasing the amounts from foreground to background, until he was painting almost exclusively with the fog paint mixture alone.

Socked In was painted on oil-primed Fredrix canvas, which was taped to a 40-by-60-inch (1.2-by-1.5-meter) piece of plywood for support while drawing. Once the initial pencil work was completed, Atwater stretched the canvas himself. He used a 1¹/₂-inch (3.8-cm) flat Robert Simmons white sable brush for the background and prefers numbers 0, 1, and 2 white sable, either Robert Simmons or Winsor-Newton, for details.

Each year, Atwater selects one of his best watercolors from the previous year's work to use as a study for a large oil. In the watercolor *Clearing by Noon*, the artist created some blue sky on the right, leaving the left side in deep fog. Not satisfied with the effect, he later eliminated the blue and reworked the overhead fog into a dark band to create the more focused and dramatic oil, *Socked In*.

CLEARING BY NOON
15" x 34" (38.1 x 86.4 cm), watercolor, 1985

Christopher Blossom
PAINTING BACKLIT SCENES

OUTER HARBOR,
BRIXHAM, ENGLAND
20" x 35" (50.8 x 88.9 cm), oil, 1988

A quiet evening descends on England's Brixham Harbor in this turn-of-the-century scene. Artist Christopher Blossom used charts of the harbor, old photographs, and a detailed street map to create the view. "In a hundred years," he says, "not much has changed."

The sky, set off here by the dark sails and the dusky hillside town, is an important element in a backlit painting. Blossom gave both sky and water an initial wash of pale, grayish lemon yellow, set off by darker washes of burnt sienna and ultramarine blue. The play of cool yellowish moonlight against the warmer lights emanating from the houses and boats provides additional contrast and interest.

On the deck of the trawler in the foreground men are setting sail, preparing for a night of cod fishing. The vessel's tanbark sails were built up with a mixture of burnt sienna, alizarin crimson, and Prussian blue, with some green to tone down the reds. The hull is a mix of Prussian blue and burnt sienna, giving it a greenish-black cast. The real sails' rich color came from the tannin used to preserve them, the artist notes. Each coastal stretch had its own formula—one way of telling a boat's home port. "In parts of Scotland," he reports, "a local preservative turned the sails black."

Blossom roughed in the basic shapes and buildings early, street by street, with the help of an old town plan. The rooftops seemed too cold and bright at first, so he glazed them with burnt sienna and a touch of green to warm them up and tone down the value. Lights in the windows were carefully varied—some squares bright, others faint and set off-center. "If there's a lamp in front of a window, it looks different from a lamp in the corner of the room, where all you get is a little bit of light on the walls," Blossom explains. "Painting it that way adds variety. If all the windows looked the same, it wouldn't be as interesting."

For the water, Blossom started with a fairly literal reflection broken up by minor surface variations, then added a cat's paw of wind to the side of the bow. Additions of viridian green in the boats, water, town, and sky helped to unify the piece.

Sailing into Britain's Lowestoft Harbor could be tricky. With seas pounding across the entrance, boats had to navigate parallel to the shore, between two sandbars, then turn into the breakwaters just 100 feet (30.5 meters) apart—all the while fighting a strong current. In this scene from the late 1800s, onlookers at the pier watch as a trawler corkscrews in a southeasterly gale.

THREADING THE
OUTER BREAKWATERS,
LOWESTOFT, ENGLAND
*22" x 33" (55.9 x 83.8 cm),
oil, 1985*

PEOPLE

James Harrington
CREATING MARINE BLUES

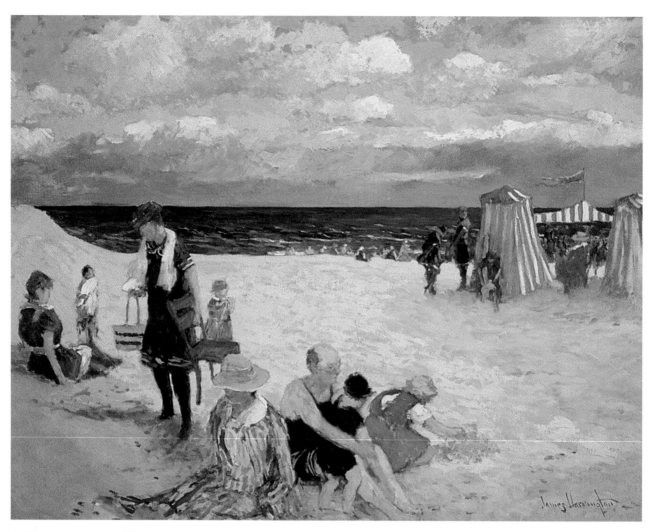

A CHANGE IN THE WEATHER
28" x 36" (71.1 x 91.4 cm), oil, 1988

First, yellow ochre diluted with turpentine was rubbed over the entire linen canvas with a muslin rag. Next, horizon, sea, and major figures were blocked in. The artist then switched to bristle brushes, allowing images to evolve spontaneously until the painting was complete.

"I think of my paintings as Impressionistic, though not the optical Impressionism of my French heroes," says James Harrington. Accordingly, his technique is direct, loose, and bold. The artist's favorite colors are the blues, which are well represented in *Change in the Weather*. The painting's upper sky is thaline over cobalt; the lower portion, manganese turquoise and cerulean. The color of the water, inspired by the artist's Nantucket surroundings, is ultramarine blue with a rose madder overlay, above a band of viridian green and yellow.

Malagash Regatta, on pages 104–5, was also inspired by the sea—beautiful but empty Malagash Bay, in Nova Scotia, which Harrington thought would be a great place for racing boats. Again, the blues predominate: The sky has a cobalt ground, and the water is thaline mixed with cobalt, grading to cobalt and yellow ochre; the man standing at the far left is highlighted with turquoise and ultramarine, the woman wears a cobalt hat, and the man next to her has an ultramarine jacket and cerulean highlights on his pants; there are even touches of ultramarine blue in the grass.

Harrington prefers Blockx paints, manufactured in Belgium, and has enough tubes to fill seven feet (2.1 meters) of shelves. Though costly, the colors are so rich and powerful, they last for years, he notes.

Harrington often has no set subject in mind, allowing a painting to develop by itself through changing shapes and color harmonies. One work, for example, began with a large expanse of snow and a number of buffalo in the foreground, and a distant timberline shrouded in fog. A day or so later, the buffalo and snow had been transformed into an ice floe trapping an ice-encrusted boat, and the trees had become a distant shoreline. The image finally evolved into four men burning brush in a fall field. "In each of these stories, the concept was the same—to create space," Harrington explains. "I just had to work until the composition, colors and subject produced the feeling for space that had been at the heart of this work."

At the start or end of the day, Harrington often scrapes down the surface of the work in progress with a variety of painting knives, undoing much of what he has applied. Some of the colors below start to show through. Little flecks touch and mix, eventually building up a rich patina. While he paints every day, the artist does not feel compelled to get to the end. "I never put the paints away," he says. Often there isn't any end in mind. It's the process that takes over, and the process that I enjoy."

Harrington often makes many pen sketches on site, using his wife, Elizabeth, as the model. Typically, he prefers to paint in his studio, close to the coffee pot, and away from gritty sand and other distractions.

James Harrington

LEADING THE EYE WITH METER

The energy in *From Dublin's Fair City* derives from its meter—a rhythm set up by boldly intersecting lines and the asymmetrical figure placement. To drive the lines, the slant of the deck is exaggerated, and further emphasized by the angle of the tug. The uneven placement of the people on deck keeps the eye moving across the scene. As the artist, James Harrington, explains, "If there were two grapes on the left, two in the center and two on the right, you would have a balanced meter—it doesn't travel. Similarly, a meter of two-three-one could prove unsuccessful. But put three grapes on the left, two in the center and one on the right, and the painting begins to move. It's something artists do naturally—as they

adjust color, mass, and value—to bring whatever the meter is into harmony." Here, a color further strengthens the tempo: The blues of the woman and child on the far right—cobalt and thaline, respectively—blend with the background, unlike the other figures and dogs, which are darker and have a greater compositional mass.

From Dublin's Fair City was inspired by a photograph the artist found in an old book. Prior to the 1920s, the task of walking the dogs fell to an ocean liner's butchers, but as it became fashionable to travel with canine companions, special animal handlers, like those shown here, became members of the crew. A neighbor's wolfhound was Harrington's lone model.

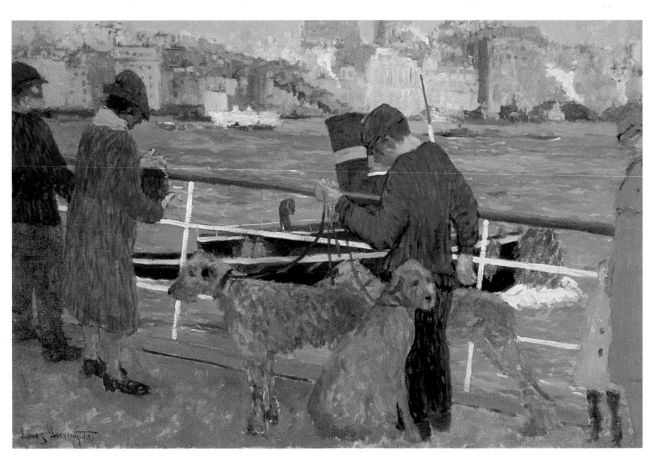

FROM DUBLIN'S FAIR CITY
24" x 36" (61 x 91.4 cm), oil, 1989

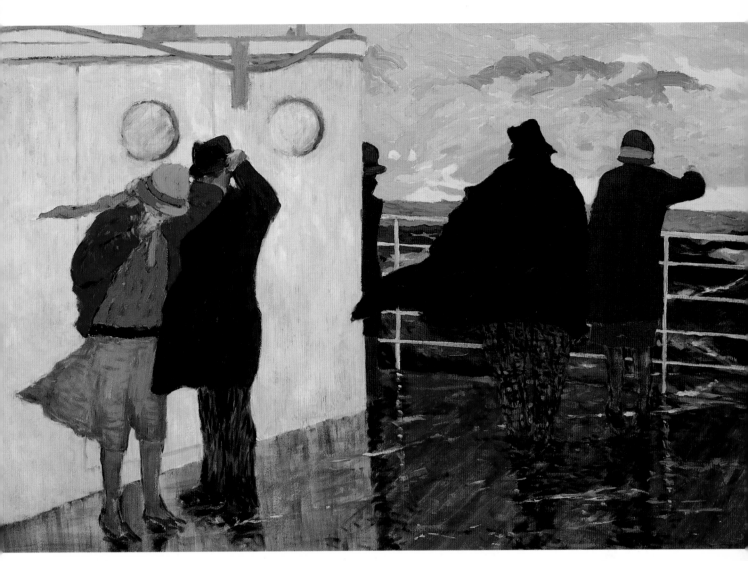

SOMETHING SIGHTED
24" x 36" (61 x 91.4 cm), oil, 1989

Meter also drives *Something Sighted*, the result of a trip taken in heavy weather aboard the ferry that runs between New London, Connecticut, and Orient Point, Long Island. "I was most interested in the gesture of the coat and clothing of the man whose back is to the viewer," Harrington explains. "For the most part, the entire composition is set down to accommodate that figure."

The speed with which the viewer scans a painting—and, ultimately, the interest the painting holds—is controlled by meter. Here, the rhythm created by the uneven placement of the darkly clad figures against a brighter background couples with the meter of the deck rail to make the figures appear as notes on a sheet of music.

Harrington uses many formulas for gray, which he calls "the queen of colors." Favorites include mixing Blockx Cassel Earth with white and yellow ochre, which yields a warm color, or with white and cobalt blue, for a cooler tint. Another frequently used gray results from combining Prussian blue, ultramarine blue, and white with a touch of red and yellow ochre. The artist also mixes Blockx Vert Compose—a gray-green Monet favored—and rose madder, creating a purple to which he adds white, which in turn produces a warm or cool gray, depending on the mixture. A favorite brush is a number 6 Egbert, whose two-inch (5.1-cm) bristles "fire" the paint on the canvas.

As he matures, Harrington is paying less attention to people's proportions and more to their action, exaggerating certain aspects, as in *Something Sighted*, so as to stress what the figure is *doing* over what it is. "Whether this could be considered a digression or an advance, I don't really know," he says. "It's just a turn my work is taking now."

KEEPING FIGURES IN PROPER SCALE

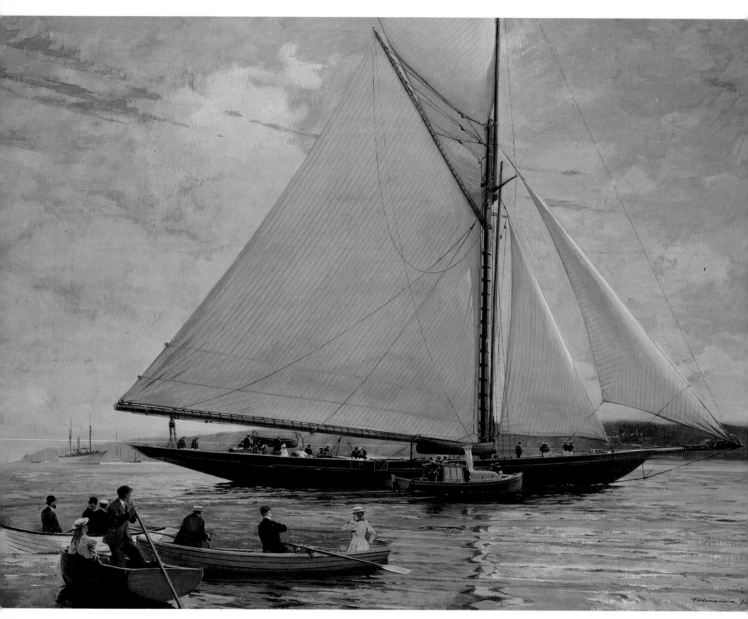

LADIES' DAY AT COWES
30" x 40" (76.2 x 101.6 cm), gouache, 1990

The royal yacht *Britannia*, accompanied by the royal launch, sails gently to her mooring after a pleasant day of cruising in the summer of 1907. The late afternoon has a golden glow, the breeze is gentle. In the foreground, spectators watch the royal party with interest. Seated amidships, together in conversation, are British King Edward VII (in a white hat) and King Alfonso of Spain.

Cowes, on the Isle of Wight, just off Portsmouth and Southampton, is the yachting center of England—equivalent to Newport, Rhode Island, in the states. Artist Frank Wagner spent considerable time there, accompanied by his English wife, Elizabeth, gathering research for the painting at Beken's, the major maritime photography studio in England, and at the Portsmouth Naval Museum. The

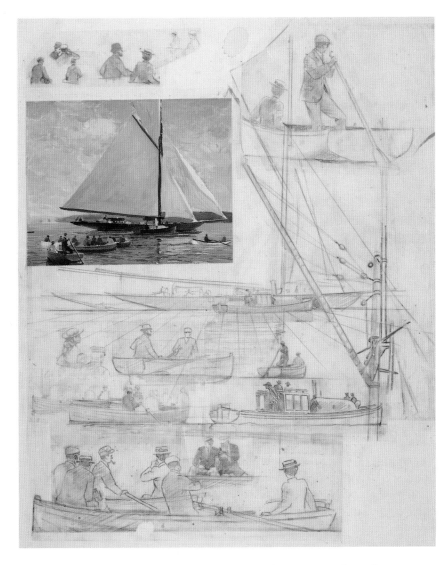

In this 12-by-18-inch (30.5-by-45.7-cm) composite, an assortment of pencil sketches on tissue and a small color study reveal how Wagner put together Ladies' Day at Cowes.

spectators' outfits were taken from several pictures, altered to suit the artist's needs. The bearded man in the bowler hat at the left, for example, was originally standing on the lawn of the yacht squadron.

The composite above shows pencil sketches and a small color study prepared for the work. Perspective lines were drawn to keep the on-deck people and the foreground figures in the right scale. Converging lines gave Wagner their proper relative heights. To find the most interesting foreground grouping, Wagner moved the pencil tissues around, eventually eliminating two boats he found unnecessary. The color study was made to work out the values of the painting and explore color relationships.

After Edward's reign came King George V, a racing enthusiast. He ordered the royal yacht's bulwarks lowered and had the vessel fitted with a big Bermuda rig. Then he raced her with the J-boats, where she did very well. Before he died, however, the king gave orders that the *Britannia* be scuttled. One rainy morning in July, 1936, after she had been stripped of royal gear, a charge was detonated in the hold, the hull was breached, and the boat sank off St. Catherine's Point, Isle of Wight.

Frank H. Wagner
GROUPING FIGURES EFFECTIVELY

Spring Trials documents a piece of America's Cup history. In the foreground is the legendary British racing yacht *Endeavor*, with her owner, aeronautical engineer T. O. M. Sopwith, at the helm. The vessel's equally famous designer, Charles E. Nicholson, of the Camper Nicholson shipyard in Gosport, England, is facing the viewer by the mast. They are on a shakedown cruise off Cowes, on the Isle of Wight, checking the sail trim and the newly designed Park Avenue boom prior to sailing *Endeavor* to America to race in the 1934 America's Cup off Newport, Rhode Island. The racing yacht in the background is *Shamrock V*, the last of five such yachts built for British tea magnate Sir Thomas Lipton to compete in earlier Cups, and purchased by Sopwith as a trial horse for *Endeavor*.

Artist Frank Wagner worked with reference photographs for most of the people on board, being careful to select middle to distant views to match the distance of the figures from the viewer—photographs of people taken up close, he notes, suffer from distorted proportions that make them unsuitable for anything but portraits. Other figures were taken from magazine clips, and the leaning figure was made up from scratch.

Wagner has had many years of experience drawing the human figure, starting at the Pennsylvania Academy of Fine Arts. "There has to be a sense of stability in the way a person stands or sits, and yet a sense of ease, fluidity, and grace," he says. "I put in as few details as possible—you can almost say these are impressions of people. The simpler each figure is, however, the more 'right' each stroke has to be." Posture and action are expressed through one or two major wrinkles in the clothes, such as the inverted curve in the seat of Sopwith's pants; for the man to his left, it is the crease under his arm. Wagner finds that if the wrinkle is placed correctly, everything else falls into place.

Figures in white can be difficult, however. If all were painted bright white here, for example, the picture would not be as interesting. For variety, Wagner rendered some in light, some in shade, and a few in mottled light. Those in shadow are not white at all, he notes, but rather blue, pink, and yellow—actually darker than the sky.

In the fall of 1934, *Endeavor* faced the U.S. America's Cup contender, *Rainbow*, owned by the Vanderbilt syndicate. Against all odds, *Rainbow* won. "Sopwith had a problem with his crew and fired them on the eve of the race, replacing them with amateurs," Wagner explains. "If she had been sailed to her potential, there would have been no competition. *Endeavor* was the fastest J-boat afloat." Of the ten such boats originally built, only *Endeavor*, *Shamrock*, and *Velsheda* survive, their vivid histories depicted by artists like Wagner.

At first Wagner arranged the central group standing together, as seen in this sketch, but didn't like the way the heads stacked up in a row.

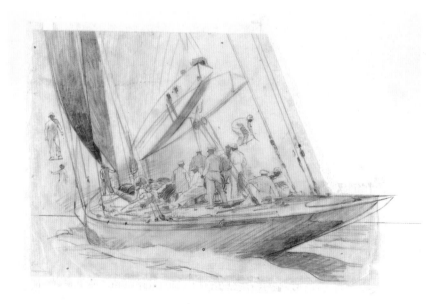

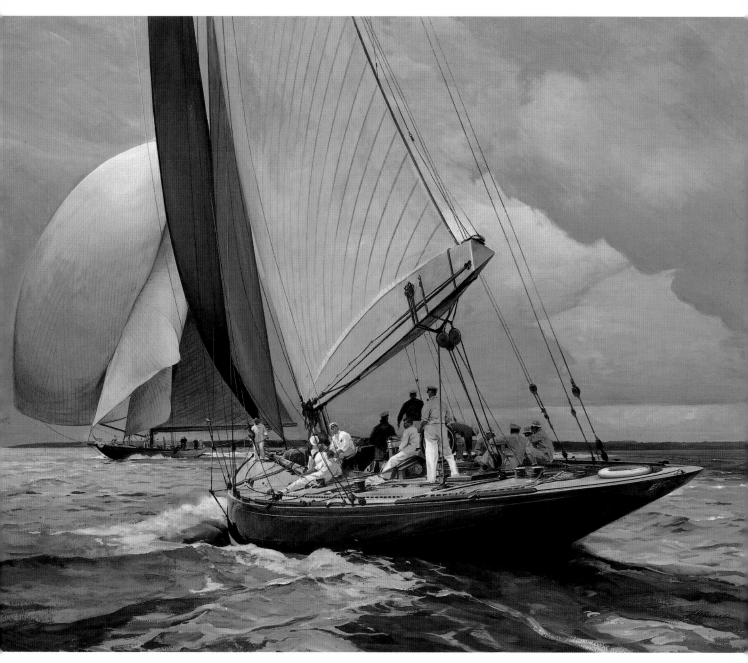

SPRING TRIALS: *ENDEAVOR* AND *SHAMROCK V* OFF COWES, 1934
30" x 50" (76.2 x 127 cm), gouache, 1989

PAINTING FROM MODELS

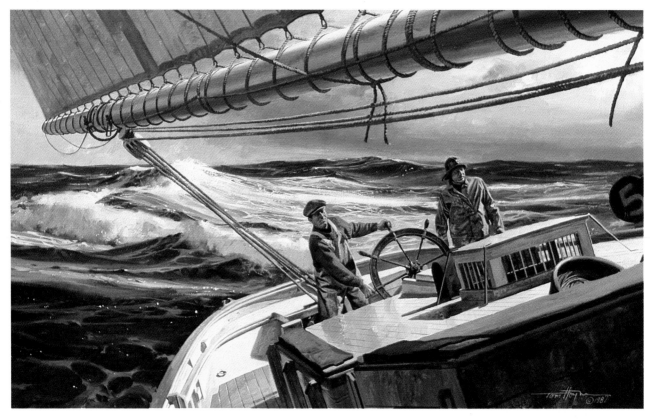

HOLD HER TO IT!
24" x 38" (61 x 96.5 cm), oil, 1987

In re-creating life aboard the great Gloucester fishing schooners, the late Tom Hoyne left nothing to chance. He studied documentary photographs, talked to a lot of people, and, to get a figure's action and perspective just right, sculpted a handmade wooden mannequin and posed it in a large-scale wooden dory. He also commissioned a ship model, on the deck of which he positioned toothpicks, scaled to the height of a six-foot (1.8-meter) man. But mainly, the artist took pictures of himself and his friends, posed in authentic fishing gear he had collected over the years.

For *Hold Her to It!*, Hoyne and his friend Charles Kessler photographed each other, posed beside a full-size model of a ship's wheel. Kessler appears as the helmsman dressed in foul-weather gear and a heavy blue sweater, which Hoyne later changed to red. Beside him stands the artist himself, in cap and an oilskin suit, disguised with a moustache, "holding her to" the compass course, and close to the wind. Even the aft end of the vessel is from a model in the artist's collection. "Tom always preferred to have something to work from," Kessler remarks. "He didn't make it up out of his head—he knew it gets off somehow. It's just not accurate."

*Hoyne used this wooden model,
which he posed in various positions
in a large-scale dory.*

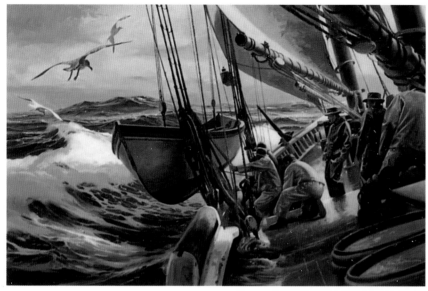

COMING ON FISH
24" x 36" (61 x 91.4 cm), oil, 1981

*In order to capture the
relationship between a figure's
pose and its surroundings, Hoyne
photographed himself in various
positions. The transition from
photograph to painting is clearly
evident in these works.*

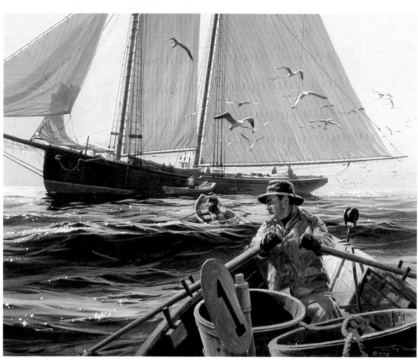

*HARRY L. BELDEN PICKS 'EM UP
24" x 30" (61 x 76.2 cm), oil, 1978*

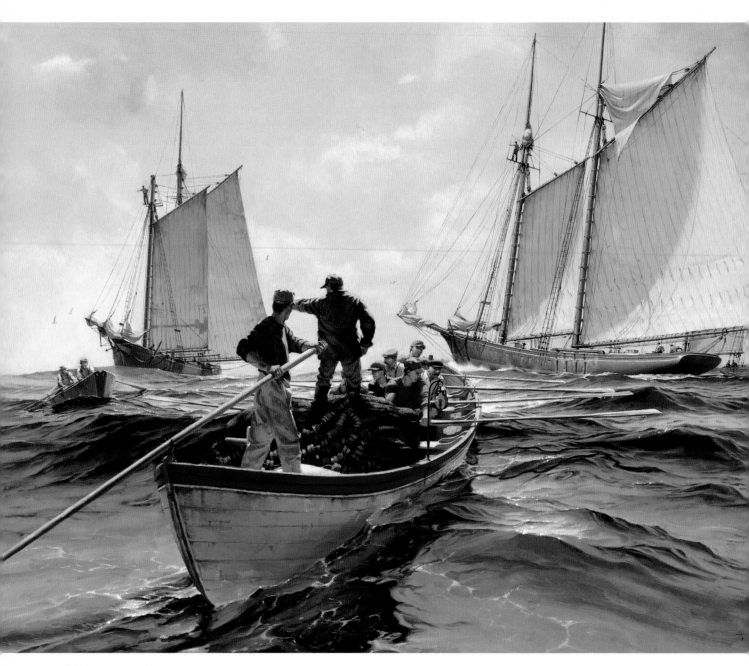

WORKING A SCHOOL
20" x 30" (50.8 x 76.2 cm), oil, 1990

The composition for Working a School *was developed in this thumbnail (shown actual size), which Demers tacked to the wall as he worked.*

A fleet of Gloucester fishing schooners has come upon schooling mackerel, some 50 miles (80.5 kilometers) off the New England coast. Lookouts, high in each schooner's rigging, point to the find. When the vessels catch up with the fish, the massive pile of net in the foreground seine boat will be cast overboard to corral them. Once they're loaded on board, it's a race back to the fish market in Boston.

Inspired by the tales of James Brendan Connolly, son of a Gloucester fishing schooner captain, artist Don Demers wanted to create a scene with plenty of action and depth. He accomplished both by using strong abstract shapes and contrast changes, especially in the dramatic highlights at the top edge of the seine boat's railing and the deep shadows of the net. The receding plane is further emphasized by the large wave in the foreground and the small patterns in the distant sea.

The painting, which won the Thomas M. Hoyne III Award at the 1990 Mystic International competition, is an asymmetrical composition based on a symmetrical format. The focus of attention—the seine boat—is framed by schooners on either side, and the curve of the seine boat's bow is reflected in the sweep of the bowsprit behind it, bringing the viewer's eye back into the scene.

The fluidity and strong abstraction of the water in the foreground are critical in giving the painting movement. In an attempt to capture its looseness, Demers let his arm "feel as much like a wave as I could," while visualizing the sea and "letting the paint do what it wanted on the surface." The water is composed of raw sienna, ultramarine blue, burnt umber, and cadmium red medium, with additional strong passages of viridian and yellow ochre. "I was not afraid to go extremely deep with the reflection," the artist comments. "There is nothing timid about that big, rolling sea." The slightest turn of color yielded the subtle, mysterious tones that are critical reference points for the stronger hues. To create the lick of foam, Demers painted it in lightly, then went back in with the sea color to break it up. "Take time to plan your next brush stroke then paint with confidence and brevity," he advises. "That's where the crispness, freshness, and painterly quality come in."

The figures were painted from photos of models posed in fishing gear, taken under the same lighting conditions Demers wanted for the scene. A friend rowed while Demers snapped pictures from the stern of his Whitehall. "If I have to stand them up on a slanting door to get the tilt of a deck, I'll do it," he says. "Few people can draw convincing figures straight out of their heads. They shouldn't be made up. That's the biggest mistake—you can spot it a mile away." Overrendering, on the other hand, can stiffen a figure. The only guide Demers used here was a soft graphite silhouette, drawn right on the canvas. He painted the foul-weather gear directly, and exaggerated the height of the helmsman somewhat to dominate the composition. The other figures are essentially a series of portraits, rendered with as much detail but more softly, and with less contrast.

Christopher Blossom
CROPPING TO CREATE INTEREST

Christopher Blossom is drawn to the past, when life at sea often meant hardship and rugged self-sufficiency. In this scene from the 1930s, an oyster sloop heads for Bridgeport, Connecticut, at the end of the day, after the last drift. As the artist explains, oystermen drifted over the oyster beds with the tides. The drift began upwind and uptide from a bed and ran from 300 to 1,000 yards (274.3 to 914.4 meters). A sloop carrying a captain and a two-man crew worked five dredges; when they were full, the jib was released, the sloop headed into the wind and slowed down, and the dredges were unloaded and then heaved over again to continue the process. At the end of a drift, when all the dredges were back on board, the boat tacked its way back to the starting point and began again. After the last drift, the boats raced in, jockeying for a good unloading position at the harbor.

Blossom got the idea for *Drift* while out sailing one evening. He liked the way the light struck the wake of the boat, and how the water moved away from the hull when he was on a reach (sailing with the wind at a right angle to the sails) and decided to make a painting of it. He framed the

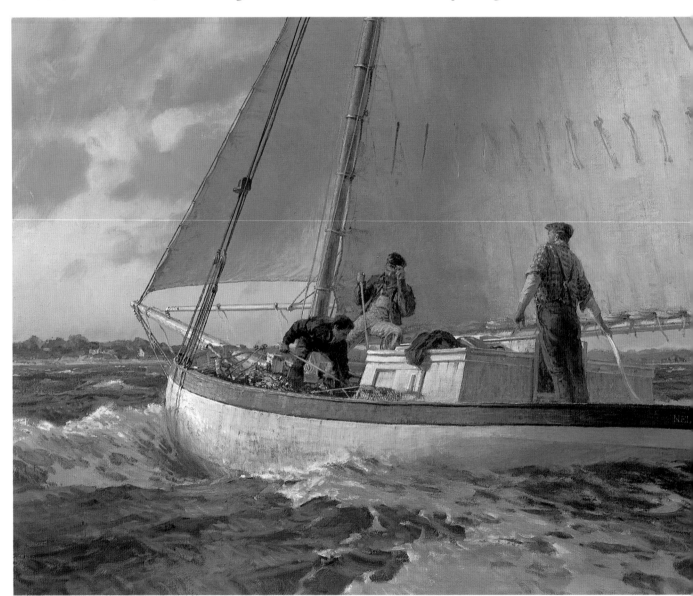

AFTER THE LAST DRIFT
22" x 36" (55.9 x 91.4 cm), oil, 1986

scene tightly, to emphasize the action on deck and portray a somewhat unusual view. "Marine painting is a pretty traditional form of painting," he says. "You can portray a ship from only so many different angles, and from just so far away. After awhile, they all have a similar feel to me. Cropping is one way to break out of that a bit and find a way to make the scene more interesting."

Sailing also helps Blossom when painting water. Working from a photograph won't help, he cautions, because the camera sees with one eye only, recording such similar values between rows

of waves that the surface looks flat. Here, the water was laid in rapidly with thin washes. "When I'm painting water, I'm thinking about movement, and I'm trying to paint it quickly," Blossom explains. "Things that happen with the brush develop into what the water is going to be. You can't anticipate it."

The foam was handled with a light side and a shadow side, matching the lighting of the side of the wave it was riding on. Underneath it is an area of translucence, where bubbles are coming to the surface, such as in the wave at the oyster sloop's bow. The sails are a mixture of blue, yellow ochre, and green, mixed with white and containing very little medium. Each pigment layer was scrubbed into the surface and then wiped away, leaving a rich patina.

Blossom recruited friends to pose as the oystermen. He finds that he often slows down inadvertently at this point, adding details until the figures look overworked. "Keep in mind that they're just another part of the painting," he advises. "Try to paint figures in a fresh and direct manner, to match the feel of the rest of the work." He blocked in the dark shapes first, then added lights, and applied details with a number 6 sable, which he finds gives more control than a bristle brush.

PAINTING FAT OVER LEAN

SURF FISHING ON NAGS HEAD
24" x 36" (61 x 91.4 cm), oil, 1988

Surf Fishing on Nags Head represents a departure for artist West Fraser. The scene—the outer banks of North Carolina—is recognizable, but it was based on an abstract design. Fraser began by slashing in bold shapes for the three major elements: buildings, beach, and surf. The darks are lean washes of turpentine and pigment, painted over a grayish, purple-blue underpainting, which shows through in the foreground shadows, buildings, clouds, and waves. On top of that, he applied the sky, cutting around the houses, where a few more tones were added to vary the roofs. Stripes of late-afternoon sunlight falling across the beach were laid in with thick, yellow-orange and green pigments, fat over lean, contrasting with the red-browns of the sand and conveying a rich late afternoon glow.

Many artists base their palettes on the concept of lean and fat pigments. Dark pigments are lean, says Fraser, because they have been thinned out with turpentine and mediums; warmer hues, such as cadmiums and whites, are painted without thinners, or less medium, and so are called *fat*. Fraser builds up a painting from darker pigments, mixed with 50 percent thinner, to brighter and lighter passages, without any medium or thinner. "The best, most skillful painting is simple," he says. "When possible, one builds from lean to fat because the darks are laid down first and if one can create a strong image simply, then I believe it's best. If your evidence of method is one of a struggle, then the surface quality becomes confused. My approach is one that is direct. I strive for simplicity." Also, since oil-rich pigments take longer to dry, painting fat over lean ensures that the bottom layer will dry as rapidly as the top. Otherwise, the layers may not adhere, and the painting will crack. "If you follow my suggestion, this should not be a problem," notes Fraser.

Unlike the bold, direct handling of *Nags Head*, Fraser painted the watercolor *Tarpon on a Fly*, a scene from the Florida Keys, with careful, delicate glazes. He brought the fish forward in the composition with dark tones and the whitest whites. The fish's scales are merely suggested; any more detail would stop the action. The grayish-yellow sky received a final glaze of white tempera to push it farther back, carefully painted around the water droplets, where the white of the paper shows through.

In the studio, Fraser's watercolor technique involves a gradual color buildup through glazing, applying large areas of paint at a time with a wash, on dry paper—a process he describes as "anxiety-creating." In watercolor, unlike oils, mistakes cannot be painted over or easily scraped off. "You sit there for hours and hours and try to figure what to do next—and be careful, very careful. With some watercolors, I'm about to go *crazy* to finish them," Fraser says.

With both paintings, the artist used magazine clips for the figures, altered to suit his needs. "You find someone in a stream throwing a flyrod and you change it," he says, "put a hat on him, stick him in a boat." In each case, he has hung the heads along an invisible line, a device to place the viewer's vantage point at ground level.

TARPON ON A FLY
13" × 21" (33 × 53.3 cm), watercolor, 1988

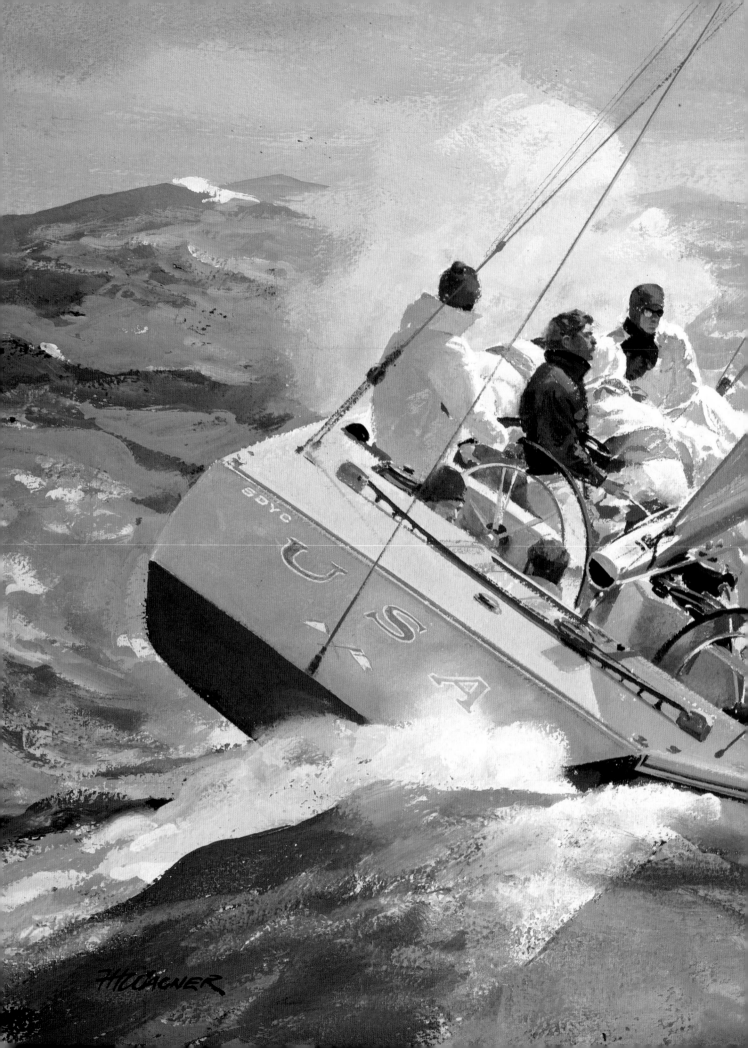

RACING

Frank H. Wagner
INVENTIVE PROBLEM SOLVING

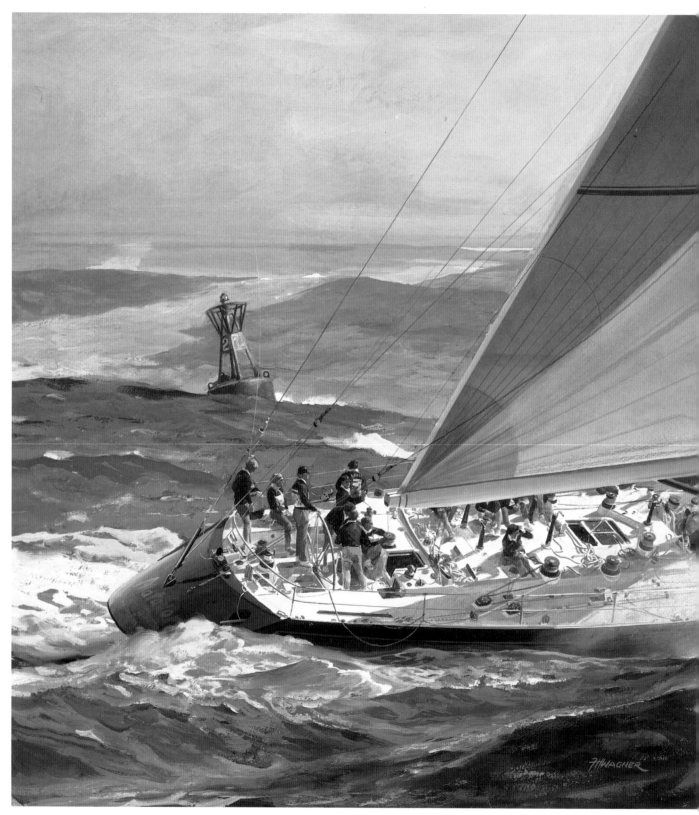

MATADOR OFFSHORE
46" x 32" (116.8 x 81.3 cm), gouache, 1987

A painting can be changed right up to the end—and in this case, even beyond. The more Frank Wagner studied his painting of the racing sailboat *Matador,* the less satisfied he felt. "I just didn't like what was happening with the jib in the bow section. It ran up along the line at the edge of the painting and there was nothing I could do to avoid the parallelism," he recalls. So he got out a heavy matt knife and cut the panel in two, resulting in the "finished" painting he later sold (left) and an "extra" piece (right), which his son appropriated for his dormitory room.

To paint *Matador,* an 81-foot (24.7-meter) Maxi designed by German Frers in 1986, Wagner worked from a photograph taken close to shore, but relocated the Maxi far out at sea, plowing through heavy rollers. The yacht has a good lead in this race, he notes—the crew is relaxed, concentrating on the next mark as she beats into the wind.

Wagner's solution to the troublesome composition is as direct as his painting method, the result of years as a commercial artist. He works quickly, blocking in color in just a few hours. "I try to let the brush float in my hand, expecting it to do something interesting," he says simply. "When it does, I try to stop." Originally, there were two boats in this scene, but when the background became too busy, Wagner painted the second one out, replacing it with a big ocean buoy.

Wagner laid in the sea and sky first, then the hull and the figures. The sea was later reworked, with more white added around the stern of the boat to better separate its dark hull from the value of the water. A smudge of spray interrupts the vessel's hard lines.

After years of working small in commercial illustration, Wagner enjoys the freedom of his large marine scenes. For panels this size, he uses round and square sable watercolor brushes, numbers 12 to 18, switching to 8s and 6s for details. He starts with a drawing on tissue, then does a rough color composition to establish the mood.

BALANCING SPONTANEITY AND CONTROL

GOSSAMER TAKE DOWN
30" x 40" (76.2 x 101.6 cm), watercolor, 1988

Willard Bond pushes watercolor to the limit, and in a variety of ways. On the one hand, spontaneous floods of color become what he calls "controlled accidents," creating abstract forms, as in *Toward Skagin Light*. On the other, carefully manipulated washes capture delicate details, such as the translucence of the collapsing Space Age spinnaker in the artist's tour de force, *Gossamer Take Down*.

Bond put a great deal of thought into *Gossamer Take Down* before brush touched board. In fact, the artist claims, he spent more time cutting a mask from masking tape than on the painting itself. "I don't use opaque white," he explains. "What is left white is the board itself." When it comes to color, however, he prefers washes, often applying them dark to light—the reverse of traditional watercolor technique. The key to his unusual procedure, which in some ways is more suited for oil than for watercolor, is his painting surface. Bond uses Schoeller-Hammer hotpress board, which is slick as glass, enabling him to wipe off color easily. If any unwanted pigment penetrates the board, he removes it with laundry bleach. "Don't try this on any other kind of paper, and *don't* use a sable brush!" he stresses.

For Bond, removing paint is as much a part of the artistic process as is putting it on. At one point, the shadows in the gossamer sail were darker and more extensive, but after deciding on a more ethereal effect, the artist used a wet tissue to wipe down the color to the board again. The remaining edges softened as they dried.

Toward Skagin Light was painted in 1979, while Bond still worked on 400-pound Arches watercolor paper. "It's just two small boats, way out in a very large sea, who've got a tiger by the tail," Bond explains. The scene's vastness is enhanced by the white background, which also helped the artist convey the feeling of air.

After masking the wave on the right and the tops of the other waves with liquid Friskit, Bond wet the paper one section at a time and, working wet-into-wet, laid in subtle washes of mauve, blue, and viridian green. He then turned the painting upside down, letting the colors pool against the mask, and drained them off, wiping here and there with tissue. After the painting dried, he picked up the Friskit, leaving a crisp edge.

Over the years, Bond has become so familiar with watercolor that he can control it without a careful, preplanned drawing—he now typically works longer on the idea than on the actual painting. *Toward Skagin Light* took a couple of hours to plan and less than half that time to execute. "It's very simple, just a gesture—like a Haiku poem," he says. "I got totally out of the way of the painting and it happened very quickly." Years later, it remains one of the artist's favorites.

TOWARD SKAGIN LIGHT
30" x 40" (76.2 x 101.6 cm), watercolor, 1979

Frank H. Wagner
COLOR STUDIES

LIBERTY
12" x 16" (30.5 x 40.6 cm),
gouache, 1987

To remain fresh, Frank Wagner occasionally takes time out for a quick color study, making no attempt to "stay within the lines." The carefree work, painted quickly (the two shown here took four hours each), may lead to something bigger or turn into a throwaway. No matter—what counts is that while painting it, it doesn't count.

Wagner's medium is odorless, fast-drying gouache, applied to a smooth, gessoed Masonite panel or illustration board. The way the paint is applied is as important as the subject matter, he notes: "I love paintings to have an interesting stroke structure, with a pleasing textural effect. There is a sense in which it's almost accidental. I like to anticipate accidents and be alert enough to leave them in."

Liberty was the U.S. contender for the America's Cup in 1983, the year Australia took the title for the first time. Wagner blocked in the 12-meter yacht quickly, without any attention to details, and yet it's all there. Spontaneity is the key—it's a heavy-weather situation and the artist was experimenting with handling the sea in a different way, trying to capture the emotion of turbulence without delineating literal wave patterns. No attempt was made to work up any kind of sky, clouds, horizon, or wave shapes—the painting is suggestive, just an impression.

Another goal was to keep attention focused on the men and the sail, rather than on the waves and whitecaps, by eliminating all unnecessary detail. "You have to experiment," comments Wagner. "Sometimes you really hit on things when you're in a sketch mode. Accidents happen. But even if they are good ones, you have to subordinate the nuances to the effect of the picture as a whole."

Intrepid, the only two-time winner of America's Cup (in 1967 and 1970), was loosely painted over a sienna-umbery tint, flecks of which show through here and there to warm the scene. Wagner's intention was that the values be right, that it "feel good," and that the boat sit nicely in the water. He likes the relationship of the quiet, Corot-like colors. "I didn't go after the painting with any tense preoccupation," he recalls. "The glob of wave is just a big fast scumble, without any concern other than that it should relate to the hull."

The artist began by painting the sky, the top of the boat, and then the helmsman. Next came the wrinkles in the jib, then a bit more of the boat, then the sea again, with its simple, direct wave shapes. The horizon exists solely to define the edge of the boat, whose wake appears in the trough behind it.

INTREPID
20" x 30" (50.8 x 76.2 cm),
gouache, 1987

BOLD BRUSHSTROKES, BOLD COLOR

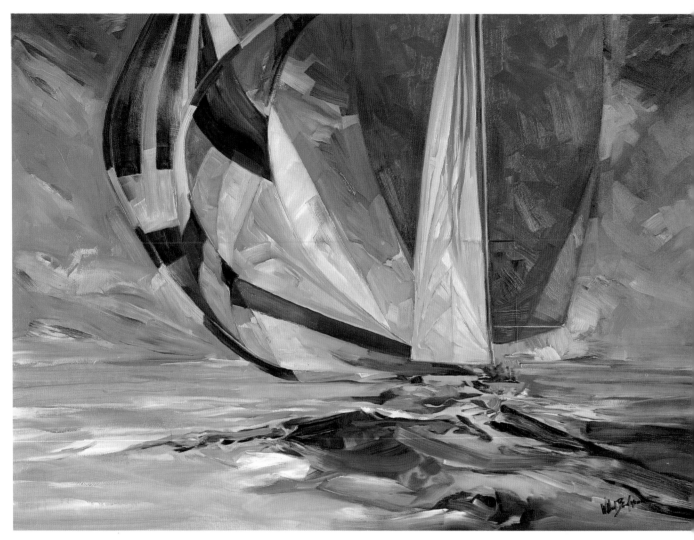

TOWARD MYSTIC
36" x 54" (91.4 x 137.2 cm), oil, 1989

Willard Bond captures the excitement of ocean racing in big oils more than 13 feet (4 meters) square. Here, two sleek yachts boil around a mark, the crews scrambling to drop a mountain of sail and raise another, all within seconds. The crew of the blue-hulled ship is busy hauling in an orange spinnaker and hoisting the jib. Meanwhile the white mainsail is luffing, picking up wind on both sides. To the left, the second ship, its new sails up, is moving away.

Wielding a large brush, Bond works quickly, sometimes violently. Impastoed reds, oranges, greens, and blues sweep together with a headlong abandon reminiscent of the great ships themselves. For Bond, an idea for a painting might come from

a series of photographs—hull from one ship, sails from another, crew from somewhere else. He used to work from careful drawings but now paints directly over a loose sketch. "I have in mind where the figures will be," he says, "but until I start, I'm not sure about the colors."

The artist's painting surface is a hollow construction door, available from any lumberyard, made of Luan mahogany, a light, strong wood that does not warp. Bond cuts it to the size he wants—sometimes getting two paintings from a 36-by-80-inch (91.4-by-203.2-cm) door—then coats the surface with gesso.

After laying in thin turpentine washes, he begins to build up the scene, attacking the surface

with a rush of paint and sometimes going through a huge tube of white in 15 minutes. If the painting fails to come together right away and he finds himself laboring, the artist just wipes it off and starts again. But in *Heads Up*, Bond didn't have to scrub anything. "It just went," he says.

When it was nearly finished, he spent most of his time sitting and observing, getting up occasionally to fine-tune a passage. These last touches may be small, but for Bond, they pull the piece together. In this case, he simplified the figures and emphasized a unifying zigzag passage that starts at the top left and moves across the ship's bow and wave splash, concluding with the final slash on the right. The painting's title has a double meaning, describing the row of heads and sounding the warning: Pay attention, here's the mark!

In *Toward Mystic*, two ocean racers head toward Mystic, Connecticut, their bloopers and spinnakers enormous with air. The sails may look like hot-air balloons, but the feeling is really more like a soap bubble wobbling through the air, says Bond. To describe their rapid movement away, he added a heavy wake.

HEADS UP AT THE MARK
36" x 54" (91.4 x 137.2 cm), oil, 1989

Frank H. Wagner
CAPTURING THE DANGER OF THE SEA

POWER REACH
35" × 50" (88.9 × 127 cm), gouache, 1986

Bucking heavy weather, the 12-meter America's Cup contender *American Eagle* drives for the mark in this gouache painting by Frank Wagner, who owns the yacht with a group of friends. A series of convergences focuses attention on the small triangle of action at the front of the boat, where the foredeck crew is setting the jib prior to taking down the giant blue spinnaker. "The wind is becoming too strong, and at this point it's beginning to be unsafe," the artist explains.

Wagner wanted a scene reminiscent of the wild waters of the Irish Sea, where notorious storms arise without warning, generating heavy, confused swells. The event is the ill-fated Fastnet Race of 1979—the greatest disaster in the history of ocean racing—in which 77 boats capsized, 100 more were knocked horizontal, and 15 sailors perished in a sudden killer storm. *American Eagle*, built for the 1964 defense of America's Cup, was among the handful of leaders ahead of the worst winds, and survived. Here, a break in the sky adds an element of hopefulness.

Originally, Fastnet Rock itself dominated the background, and there was no foredeck activity on board the yacht, but Wagner felt there was too much secondary interest, "so out went the rock, and in came the figures," he says. "But it's all there. If I were to scrub out the sky, Fastnet Rock would reappear."

The artist's seas are a complex combination of hues, including Winsor blue, ultramarine blue, burnt umber, alizarin crimson, yellow ochre, and raw sienna, along with a touch of permanent green. He adds foreign color to avoid a monotone affect. "I don't have a repetitive formula," he notes. "I play warm against cool and go for an exciting, tactile quality."

The ballooning spinnaker, blurred at the trailing edge to convey the power of the wind, adds power to the piece and makes the intricacy of the figure work all the more compelling. The spinnaker is primarily cobalt blue, with some ultramarine blue and alizarin crimson added for depth and a touch of black in the shadow. The hull is Havana lake—a very deep alizarin crimson-burgundy—with spectrum red and some indigo blue in the shadow.

Power Reach is the first painting the artist, a relative newcomer to the marine art world, ever sold. It was exhibited at the New York Armory in 1988, and was one of three of his pieces an American collector bought that day. Wagner was on his way.

BIOGRAPHIES of the ARTISTS

JOHN ATWATER

CHRISTOPHER BLOSSOM

WILLARD BOND

VERN BROE

DONALD DEMERS

CARL G. EVERS

WEST FRASER

JAMES HARRINGTON

THOMAS M. HOYNE III

LORETTA KRUPINSKI

JAMES E. MITCHELL

KEITH SHACKLETON

JOHN STOBART

FRANK H. WAGNER

JOSEPH A. WILHELM

JOHN ATWATER

Drawing on the subtlety of light and atmosphere of the Hudson River and Luminist schools, John Atwater captures the beauty and life of coastal landscapes. Since 1980, he has spent a number of weeks each summer sailing and driving along the Maine coastline, from Boothbay Harbor to Camden, gathering research material for his paintings, which he completes later in his Avon, Connecticut, studio.

Atwater was born in 1954 in Worcester, Massachusetts, and graduated from the Washington University School of Fine Arts in St. Louis. After eight years of commercial work, he devoted himself full-time to marine painting.

The artist exhibits at the Mystic Maritime Gallery, and his work is in the permanent collection of the Mystic Seaport Museum. He has received awards from the American Watercolor Society and Allied Artists of America, and is a member of the American Watercolor Society, the American Society of Marine Artists, and the Connecticut Watercolor Society, of which he is president. Prints of his work are published by the New York Graphics Society.

CHRISTOPHER BLOSSOM

Christopher Blossom's love of the sea and sailing led him naturally to maritime painting; but his greatest influence was the advice and support of his father and grandfather, well-known illustrators David and Earl Blossom. For Chris, born in 1956, it was simply a matter of following in the family tradition. By age 20, he had been awarded the gold medal at the Society of Illustrators Annual Scholarship Exhibition.

Blossom studied at Parsons School of Design in New York City, then worked for an industrial designer, where he learned to interpret technical drawings, a skill that later enabled him to look at a ship's plans, visualize its shape, and draw it from any angle he wished—useful for a maritime painter.

Blossom is a charter member, fellow, and former president of the American Society of Marine Artists. He also belongs to the Society of American Historical Artists.

The artist, whose work has been exhibited across the country, resides with his wife, Patricia, and son, Travers, in Stratford, Connecticut. Prints of his work are published by The Greenwich Workshop, in Trumbull, Connecticut.

WILLARD BOND

Willard Bond is a maverick who has seldom punched a time clock. His life has taken him from Idaho to Jamaica, West Indies. In between, he taught art, made huge ceramic murals for buildings, and spent four years acting and stage managing in New York's theater and film world.

Bond became interested in marine painting in 1976, the year of the Bicentennial and Op Sail. "Those were great weeks for me," he says. "I discovered watercolor as my medium, and my subject was all around me." Later on-board experiences in world-class racing fueled his interest in painting contemporary ocean yachts.

The artist studied at the Chicago Institute of Art and the Art Students' League in New York, and is a graduate of New York's Pratt Institute Art School. He is represented by King/Sportsman's Edge Gallery in New York, The Annapolis Marine Art Gallery in Maryland, Mystic Maritime Gallery in Connecticut, and the Arnold Art Gallery in Newport, all of which publish his prints and posters.

Bond, a fellow of the American Society of Marine Artists, won the Mystic International Award for Excellence in 1990.

VERN BROE

Vern Broe's work has appeared in *American Artist* and other magazines, including three covers for *Yankee*. Born in 1930, Broe was raised near Chicago. He studied at the American Academy of Art and later attended the University of Illinois, Chicago's Institute of Design, and the San Francisco Art Institute, learning skills that would serve him well in the world of marine art.

In 1958, Broe went to work for a prominent Chicago architectural firm. Two years later, he set up as a free-lance architectural renderer in Boston, which was at the start of a building boom that enabled him to earn a living as an artist. It also left time for summers on the New England coast—Gloucester, Marblehead, Provincetown, and Nantucket—to paint the work boats there. Eventually, he moved to Martha's Vineyard, then to Newburyport, Massachusetts, and finally to Maine, where he currently resides.

Over the last few years, Broe has spent time developing other types of paintings, including a popular series of children on the beach.

DONALD DEMERS

Crewing aboard schooners, square-riggers, and brigantines has given Donald Demers first-hand experience for painting marine subjects. His work has been exhibited extensively at the Mystic Maritime Gallery in Connecticut, where he won the Mystic International Award of Excellence in 1983 and 1988 and the International's Thomas M. Hoyne III Award in 1990. In addition, Demers's commercial illustrations, featured in many national magazines, have been honored by the advertising clubs of Boston and New Hampshire, as well as by the Society of Illustrators in New York.

Born in 1956 in Lunenburg, a rural community in central Massachusetts, Demers developed an early interest in marine art while spending summers with his grandparents in Boothbay Harbor, Maine. He was educated at the Worcester Art Museum and the Massachusetts College of Art in Boston, then worked as an illustrator, concentrating more and more on marine subjects.

Today the artist lives in Kittery, Maine, with his wife, graphic designer Francesca Mastrangelo. Limited-edition prints of his work are published by Mystic Maritime Graphics.

CARL G. EVERS

Carl G. Evers is the grand master of marine art, a man whose work has been admired and emulated by students and colleagues around the world. Evers was born in Germany in 1907, to a British father (a marine engineer) and a German mother (an artist). Evers earned honors at London's Slade School of Fine Arts, then worked in Sweden for 16 years as a commercial illustrator in charge of European advertising for the automotive giants Ford, Packard, International Harvester, and Jeep. While in Sweden, he began painting ships for the Swedish American and Johnson lines.

In 1947, Evers emigrated to the United States, where he decided to pursue his goal as a marine artist. He traveled by freighter to San Francisco, sketching water, waves, and ports along the way. He eventually settled in New York, where he soon found work painting vessels for Grace Line, Farrell Lines, United Fruit, Moran Towing, Cunard, and other ship companies.

Since then, Evers's work has appeared in many books and magazines and won many honors. A collection of his art, *The Marine Paintings of Carl Evers*, appeared in 1975, and prints of his work are published by The Greenwich Workshop in Trumbull, Connecticut, and the U.S. Naval Institute print program. The artist lives with his wife, Jean, in Southbury, Connecticut.

WEST FRASER

West Fraser is an avid conservationist who has devoted much of his life to preserving, in paint, native coastlines pressured by development. Born in 1955, his passion was shaped at age 10, when he moved with his family, prominent loggers and developers, from Georgia to Hilton Head Island in South Carolina, where he witnessed the development of thousands of acres of wild, undeveloped land into an international resort. The experience profoundly influenced his evolution as an artist.

A member of the American Society of Marine Artists, Fraser won the Mystic Maritime Gallery's International Award of Excellence in 1985. He has been featured in many national magazines, as well as in the 1988 book *Yacht Portraits*.

The artist is represented by Grand Central Galleries and King Gallery in New York, Montgomery Gallery in San Francisco, Mystic Maritime Gallery in Connecticut, Bayview Galleries in Camden and Portland, Maine, Atlantic Gallery in Washington, D.C., and the John Stobart galleries on Hilton Head Island and Boston. Prints of Fraser's paintings are published by Janus Prints, Hilton Head Island.

JAMES HARRINGTON

During his final semester in a New York City grammar school, James Harrington, then a rebellious and reluctant youth, spent more time creating pastel murals on blackboards than attending classes. He was already an accomplished draftsman. Later, as a student at the New York School of Industrial Art, the Cartoonists and Illustrators Institute, and the Art Students' League—all attended briefly—he concluded that his proper course lay in independent study.

Now a successful artist, Harrington is just as rebellious today. "There are a bunch of rules for conventional paintings, such as leading the eye, never putting the horizon line in the middle of the picture, and so on. I scrap that and just go ahead and do it," he says. "It keeps me fresh."

Harrington is a member of the American Society of Marine Artists and the Artists Association of Nantucket, where he lives with his family—a fitting habitat for this painter, whose art gives testimony to the people who live by or depend upon the water's edge for their livelihood.

He is represented by South Wharf Gallery in Nantucket, Mystic Maritime Gallery in Connecticut, Seraphim Gallery in Englewood, New Jersey, and the Hermine Merel Smith Gallery on Martha's Vineyard.

THOMAS M. HOYNE III

Thomas M. Hoyne III grew up in Winnetka, Illinois, just a block from Lake Michigan. But his interest in the great fishing schooners began during boyhood summers in Maine, at a camp in Acadia National Park in Bar Harbor, and at his grandmother's cottage in Ogunquit.

Hoyne attended the University of Illinois and Northwestern University, then served four years in the Navy, in the South Pacific, during and after World War II. Many hours standing watch deepened his knowledge of the power and rhythm of the sea.

For 35 years, Hoyne worked with top ad agencies and corporations, here and abroad. When cancer was diagnosed in 1972, he gradually switched from commercial to fine art, painting what he wanted: marine subjects, eventually becoming a fellow in the American Society of Marine Artists. He died in 1989, at age 65, but his work can be found in private, corporate, and museum collections throughout the world. In 1989, the Mystic Maritime Gallery established an annual award in his name, given to the artist whose work best documents an aspect of the marine fisheries industry of yesterday or today. Prints of Hoyne's work are published by several museums, as well as by Janus Lithographs, Hilton Head Island, South Carolina.

LORETTA KRUPINSKI

Classic wooden boats, lighthouses, and working harbors are Loretta Krupinski's favorite subjects. Krupinski, an avid sailor who has been drawing since childhood, grew up on Long Island. Today, she lives with her daughter in Old Lyme, Connecticut, where she often can be found sailing and photographing area regattas and nautical scenes. "It's not enough to just copy a boat," she says. "I try to get the feel of it under sail, the gusto, a sense of the kind of day it was."

After graduating from Syracuse University School of Art in the 1960s, Krupinski pursued a 15-year dual career in illustration and fine art, including an eight-year stint as an editorial illustrator with *Newsday*. Her newspaper graphics, created with sensitive ink cross-hatchings, served her painting career well, helping her to develop a unique style of interweaving color, which she carries into her children's-book illustrations.

Krupinski is on the board of directors of the American Society of Marine Artists, and is represented by the Mystic Maritime Gallery in Connecticut. Limited-edition prints of her work are available through Janus Lithographs, Hilton Head Island, South Carolina.

JAMES E. MITCHELL

"I love to paint stormy raging skies and rough seas that only a few would want in their living rooms," comments James E. Mitchell, an avid offshore-racing and -cruising sailor whose studio is in Newport, Rhode Island.

Mitchell's interests and assignments have taken him all over the world, sailing aboard cruising racers, square-riggers, merchant tankers, freighters, passenger liners, fishing vessels, hydrofoil prototypes, and nuclear-powered Navy ships.

Born in New York City in 1926, Mitchell spent much of his youth sailing the coastal regions of Long Island and South Carolina. His knowledge of ships and the sea was further developed by five years of service in the Merchant Marine, during and after World War II. He then studied illustration at Pratt Institute and continued his study of fine arts and design in Paris. Back in the states, Mitchell taught fine arts at Virginia College, then earned a living as a free-lance illustrator specializing in marine subjects. A colleague in those days was fellow artist and *Marine Painting* contributor Carl G. Evers.

Mitchell is a charter member and past president of the American Society of Marine Artists. His paintings are in corporate collections and museums throughout the world.

KEITH SHACKLETON

Artist, naturalist, yachtsman, author, broadcaster, explorer, pilot—Keith Shackleton's interests are wide ranging. Born in England in 1923, he served five years in the Royal Air Force in Europe and the Far East, then joined his family's aviation business. He has represented Great Britain in international dinghy meetings, and four times crewed the winning boat in the Prince of Wales' Cup. All the while he painted, eventually becoming a full-time artist despite never having attended art school.

Shackleton is past president of the Royal Society of Marine Artists, the Society of Wildlife Artists, and the Artists League of Great Britain. Married, with a daughter, two sons, and several grandchildren, he lives on a farm near Plymouth, in Devon, England. Otherwise, he often can be found as an artist/naturalist aboard the adventure ship *Lindblad Explorer*, heading for the Antarctic, the Amazon, and other exotic ports of call.

The author of many articles and illustrations for wildlife and yachting magazines, Shackleton also has written several books, including *Ship in the Wilderness* and *Wildlife and Wilderness: An Artist's World*. He is represented in the United States by Mill Pond Press in Venice, Florida.

JOHN STOBART

The art of John Stobart, one of today's pre-eminent marine painters, fetches record prices—more than $150,000 per canvas—but it wasn't always so. The son of a pharmacist, Stobart grew up in Derbyshire, England, and emigrated to the United States in 1965 with $200 in his pocket and four paintings under his arm. Settling in Boston, he combined his classical training at London's Royal Academy of Art with a painterly technique to portray American harbor scenes in the days of merchant sail.

Today, the artist's Boston-based Maritime Heritage Prints company issues limited-edition prints of his originals, which are sold through seven Stobart galleries, from Boston to Savannah. "Everything I have done is to get that big house on the hill," the artist remarks. "People think art is a calling. But when you're an artist, you're a self-employed businessman, whether you think so or not."

Stobart maintains three homes—in Boston, Martha's Vineyard, and Hilton Head Island—and paints up to a dozen oils a year. A showcase volume of his work, *Stobart, the Rediscovery of America's Maritime Heritage*, was published in 1985, and a second book is in the works.

FRANK H. WAGNER

Frank H. Wagner's work sounds a new note in the field of maritime art. Although a professional artist for many years (primarily in commercial illustration), he sold his first three marine paintings only as recently as 1988, at the New York Armory Show. That was the same year he won the Mystic International Exhibition's Award of Excellence at the Mystic Maritime Gallery in Connecticut.

Wagner studied at the Pennsylvania Academy of Fine Art and at New York's Pratt Institute, then received a postgraduate European Fellowship grant for a year's study abroad from the Leopold Schepp Foundation. The artist divided his time between the Rijksakademie in Amsterdam and the Royal Academy in London, where he met his future wife, Elizabeth.

Back in New York, Wagner found plenty of painting assignments from such firms as Reader's Digest, Time, Inc., and Woolworth's. Then a Detroit studio lured him west, where he produced ads for the car industry for 19 years.

In 1975, the artist and his family moved to Barnstable, on Cape Cod, where Wagner soon was painting fine art full-time. Today his work is on permanent display at the Smith Gallery in New York. Prints are available from Janus Lithographs, Hilton Head Island, South Carolina.

JOSEPH A. WILHELM

In 1975, at age 52, Joseph A. Wilhelm completed his first picture, a process he found so enjoyable that within four years he had left his job at a local utility and was painting ships full-time. He never had a lesson. Today, his work is handled by the prestigious Mystic Maritime Gallery, in Mystic, Connecticut.

A native of New Orleans, Wilhelm saw his first steamship when he was six years old. "My father took me to the docks to see a British cruiser and the U.S. battleship *Arkansas*," he recalls. "I remember well holding his hand crossing the street, the ships blocked from view by the freight sheds, with only their masts towering above. We waited for a steam engine with some freight cars to go by, and then walked out on the docks to a breathtaking sight. I had found my true love."

Wilhelm has hung around the docks ever since, even learning to pilot a steamer. For years he built and sold ship models; model railroading also became a passion. Sixty years after his first view of commercial vessels, Wilhelm's passion for them continues unabated.

Wilhelm, a member of the Steamship Historical Society of America, paints commissions for steamship companies, covers for magazines, and portraits for ship lovers. He has two sons and one daughter, and lives with his wife, Maxine, in Covington, Louisiana.

INDEX